Wildflowers

of Nova Scotia, New Brunswick & Prince Edward Island

The photographs of Mary Primrose

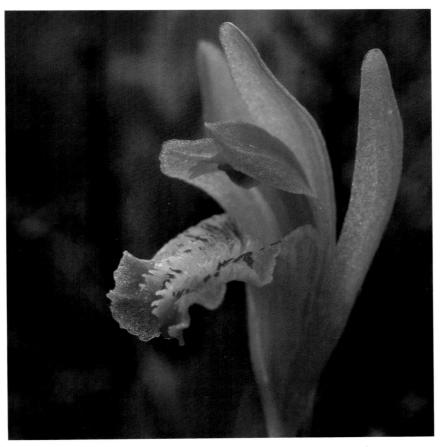

Mary Primrose & Marian Zinck

Formac Publishing Company Limited
Halifax, 1998

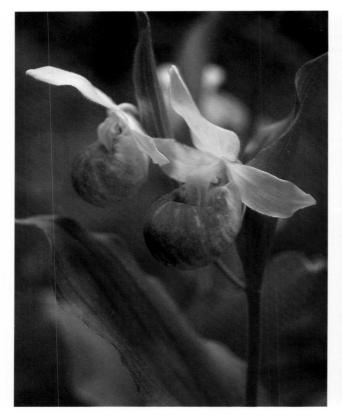

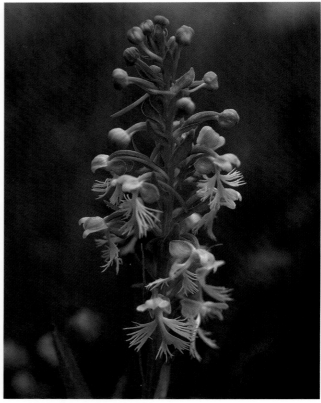

Dedication:
Fondly remembering my aunt, Frances Fraser, and her great love for the outdoors.

We acknowledge the support of the Department of Canadian Heritage and the Nova Scotia Department of Education and Culture in the development of writing and publishing in Canada.

Canadian Cataloguing in Publication Data

Zinck, Marian.

Wildflowers of Nova Scotia, New Brunswick and Prince Edward Island

Includes index.
ISBN 0-88780-450-0 paper
ISBN 0-88780-451-9 boards

1. Wildflowers — Maritime Provinces — Identification. I. Primrose, Mary, 1927–1998.
II. Title.

QK203.M35Z56 1998 582.13'09715
C98-950048-9

Formac Publishing Company Limited
5502 Atlantic Street
Halifax, Nova Scotia
B3H 1G4

Contents

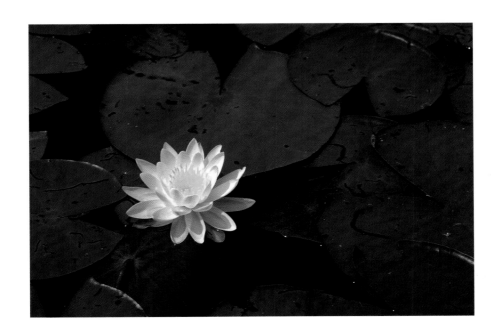

Preface

Photography has held my interest for a good part of my life, first as an amateur, then for the 19 years I served as photographer for Dalhousie University's Biology Department. Although I am now retired, taking pictures remains an important hobby for me, complementing my great love of the outdoors. I have had the good fortune of being able to visit and explore many parks in Nova Scotia — in particular Kejimkujik National Park — where I have photographed wildflowers, mushrooms, lichens, ferns, and the scenery of the Park in all seasons. Protected places such as provincial and national parks are wonderful for observing — and capturing on film — the nature of each region. When I travel outside Nova Scotia, I always search for areas where I might find some wildflowers growing. It is part of the reason I travel.

Wildflowers are always best photographed in their natural state. When I want to photograph one, I don't dig it up and take it where the light might be better, or to a place free from drizzling rain. Nor do I take it home to plant in my own garden! I photograph it just where it is. Then I can go home and tell the story of hanging over a cliff or wrapping myself around a tree, all in order to get the right angle for my flower. Some flowers in this collection have water on them because I captured their image on a foggy or rainy day, or during an early-morning walk.

One challenging yet rewarding place to take photographs is along the seashore, where there is far more to capture than just images of sand, rock, and waves. Wildflowers that can stand the harsh saltwater climate and the winds of the exposed shore thrive there. Some grow beside the water, and can be completely immersed during very high tides. Others grow higher up, on the sand or behind the beach. Our three Maritime provinces have lots of coastline where I enjoy searching for saltwater plants, but I also love to roam in meadows and woodlands in search of the wildflowers that put on such colourful displays there.

Every year I'm anxious to find something to tell me that winter is

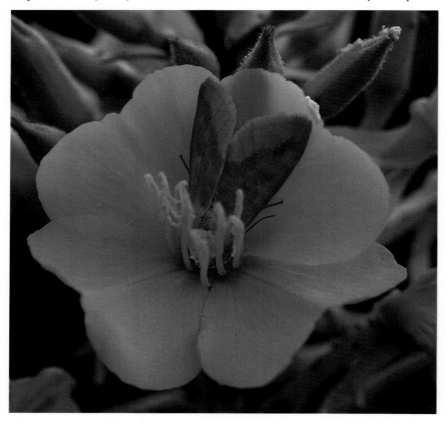

coming to an end. In late March I start searching for plants emerging from the ground. I look forward to the very early spring flowers, but it is usually some time in April before the first flowers reveal themselves in my part of Nova Scotia, where I will find some blooming under trees still bare of leaves.

When photographing something on the ground, I try to position myself in a manner that flattens as little vegetation as possible. I place my feet, camera bag, and tripod carefully to avoid disturbing the surroundings of the plant I am photographing.

Following these simple guidelines helps preserve the full variety of our Maritime wildflower species, both in nature and on film, so that those of us who love exploring the outdoors can continue to search for, and find, beauty in nature. I hope that, through this collection, I can in a small way share some of the natural beauty I have found during my many years of exploring Maritime woodlands, meadows, and seashores.

— Mary Primrose
February, 1998

Introduction

I first met Mary Primrose about ten years ago. While walking along a muddy lakeshore on a wet and windy September morning, looking for elusive Pink Tickseed flowers, I came upon a tripod and camera bag sitting forlornly under some shrubs overhanging the beach. Not three metres away, a figure in "wellies" was scrambling around on her knees, oblivious to the wet sand beneath, her face mere inches from the ground. I stopped and asked if she had lost something, and she replied that she was trying to decide which of several pink and yellow flowers she should focus on, given the background and lighting conditions. She told me she "liked to take a few flower pictures." When I passed by again an hour later, Mary was still on that same section of beach, patiently awaiting the right conditions to capture her image. In the pages that follow, we can see her patience, diligence, and passion for her subjects reflected in these beautiful wildflower portraits.

Sadly, Mary was unable to see her beloved wildflowers in book form. After a brief illness, she passed away on February 26, 1998, just after completing the Preface and Dedication for this book. She will be fondly missed by her family and her many friends with whom she shared her gentle time among us. I know that she will be proud if you, the reader, take some pleasure from these pages.

The Maritime wildflowers here are the ones that, over the years, Mary has photographed most perfectly. They are among the more than 1,500 species that can be found in the region. Some of those included here are rare, while many are easily seen in accessible places. Summer fields, ditches, beaches, rock cliffs, and city sidewalks can all host a variety of species, even well into autumn.

THE BIOLOGY OF WILDFLOWERS

Regardless of where one finds wild-

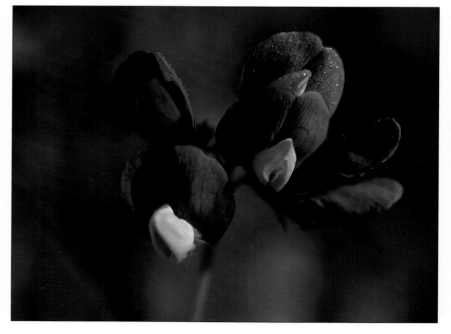

flowers, they all share one thing in common: they produce seeds. It is their biological function, and many strategies are used to attract pollinators to the flowers so the seeds can be created. Since the 1700s, scientists have used the parts of flowers to classify plants into groups based on shared characteristics. As much as possible, the descriptions of the flowers shown here use easily understood language, though the occasional use of some scientific terms is both inevitable and helpful. Here are some of those most commonly used.

Flowering plants are "vascular" (that is, they have internal "plumbing") and

generally have roots, stems, leaves and blossoms. Before a flower opens completely, it is covered by a circle of sepals, collectively called the **calyx.** Inside is the **corolla,** made up of petals, usually the most visible structures because of their variety of colours. Within the petals are **stamens** (the "males") which carry pollen, and one or more **pistils** (the "females") which receive the pollen. Not all plants have all of these parts in each flower, but their form and number do give us a way of grouping like plants together.

The arrangement and position of leaves — or in rare cases, their absence — can help in identifying plants. **Opposite leaves** are positioned in pairs, on either side of the stems, while **alternate leaves** appear at staggered intervals along the length of the stems. Plants with **basal leaves** have their leaves near the ground, but none

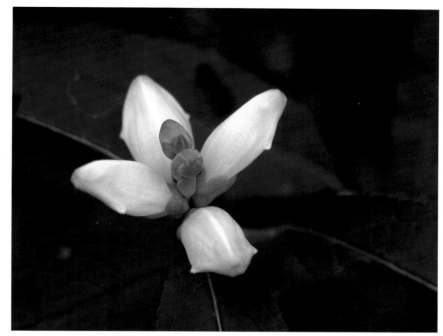

on the stalk supporting the flowers. Parasitic plants and others which don't manufacture food have no leaves. Instead, they have leaf-like structures called **bracts** along their stems. These are smaller than most true leaves and serve a different purpose.

STRUCTURE AND SOURCES

For this book, we've chosen to group and sequence the wildflowers Mary has captured starting with the species normally first to flower in the Maritimes each spring. We then go on to the flowers of early and late summer, and finish with the autumn flowers. A couple notes of caution are necessary here. The time of year a given species of wildflower first appears depends on a number of intertwined factors, including local climate, yearly weather patterns, lati-

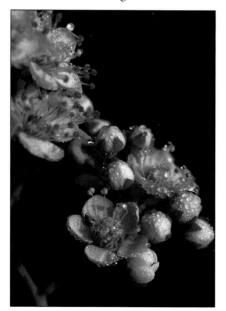

tude, and elevation. Generally, the farther north one travels, the later spring arrives and the earlier autumn frosts arrive. The same holds true for increasing elevations and distance from the ocean. And, each species of wildflower needs a particular combination of conditions to come together before it will bloom. The flowering times mentioned for each species are only general averages. For example, if, in a given year, Lupins were to flower in central Nova Scotia during the first week of July, they probably began flowering in Yarmouth County a week earlier, and in Tracadie, New Brunswick, they might not flower until ten days later. It is also difficult to be precise in trying to order plants by their flowering times within any given month or season: a species that flowers in early June at a particular

locality one year might flower late in the month the next year. It may even flower at a different time 100 metres away, so the way the wildflowers are ordered in this collection is, by necessity, only very roughly in tandem with the rhythms of the seasons. A similar set of complexities applies when we describe the height or size of any given wildflower, because such things are routinely affected by such things as climate, immediate surroundings, and the amount of moisture, sunshine, and nutrients available.

Remember, "leave only footprints and remove only memories." While I have included notes on plants considered edible (as well as those considered toxic), I want to underline the fact that no plant should ever be picked if its removal threatens the local population's ability to sustain itself. If only a few individuals are present, it is unethical to collect them for food. And, for safety reasons, one should be certain of a flower's identification before consuming it: if you're not sure, don't eat it. Always bring home the entire plant if you are going to eat any part

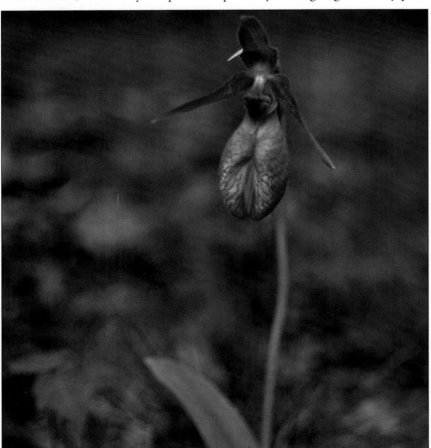

of it, so that, in the event of illness, health officials can identify the plant and ensure prompt treatment.

The common names of plants vary from place to place and can be as whimsical as imagination allows. Here, I have used the names most often used in the Maritimes. Remember, though, that some flowers are known by different names from one area to another, and such names can even vary within the same community. My sources for the scientific, Latin names of plants, and their descriptions, were Gleason and Cronquist's *Vascular Plants of Northeastern United States and Adjacent Canada* (1991), *Hind's Flora of New Brunswick* (1986), Catling, Erskine and McLaren's *The Plants of Prince Edward Island* (1985) and Roland and Smith's *Flora of Nova Scotia* (1969). For edibility and toxicity information I have relied on *Peterson's Field Guide to Edible Plants of Northeastern North America* (1977).

Any errors contained herein are my own. However, I wish to acknowledge Scott Milsom, Managing Editor at Formac, for his guidance and patience, David Redwood for editing the manuscript, and Jim Goltz for his careful (and anonymous) scientific review.

Mary's photography is a visual feast of wildflowers. I hope you enjoy the fruits of her labour as much as I have.

— *Marian Zinck*
March, 1998

Spring

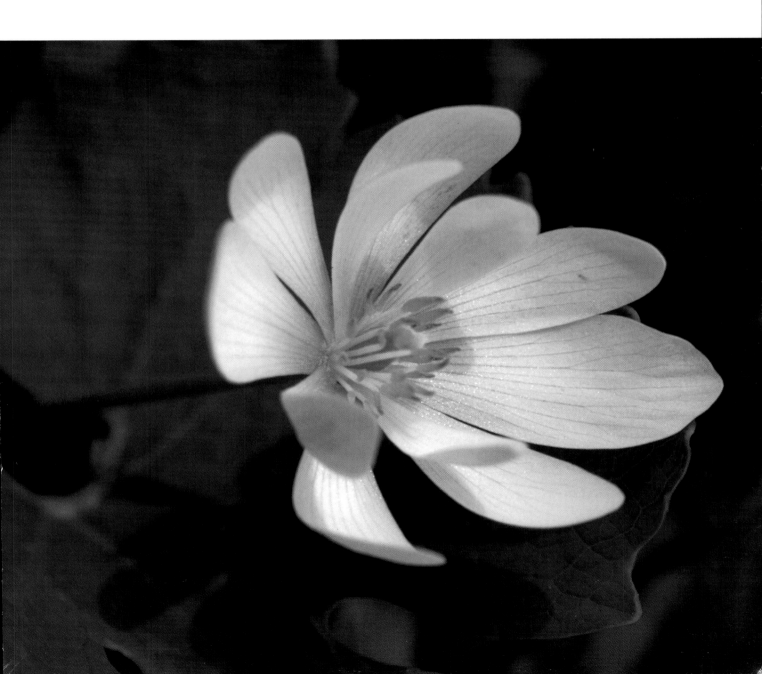

Coltsfoot
Tussilago farfara

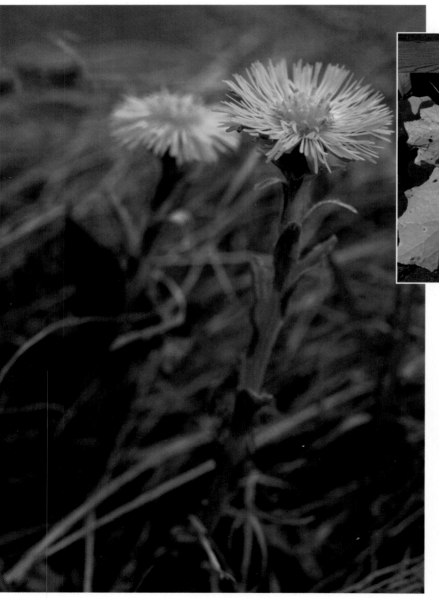

Coltsfoot (*Tussilago farfara*) is common throughout the Maritime provinces. Usually seen along roadsides, in highway verges, river beds and old fields, this dandelion-like plant prefers sandy, gravelly soil. The earliest to flower amongst our wildflowers, the sunny yellow flowers have been reported as early as mid-March, long before its leaves appear in late May. Plants can reach about half a metre in height by mid-summer. Fresh leaves have long been boiled and made into a hard candy or cough syrup. When dried, the crushed leaves make a refreshing tea.

Trout Lily
Erythronium americanum

Trout Lily (*Erythronium americanum*) is a common spring wildflower in western New Brunswick and Nova Scotia. It often blooms before the snow has melted, as early as March and as late as May. Their favoured habitat is the damp soil of open mixed forests or alder thickets. Usually found in large patches, these flowers have curved yellow petals which may be brownish beneath. The long strap-like leaves are smooth and shiny, mottled with purplish spots. Young leaves and tubers are said to be edible if boiled first.

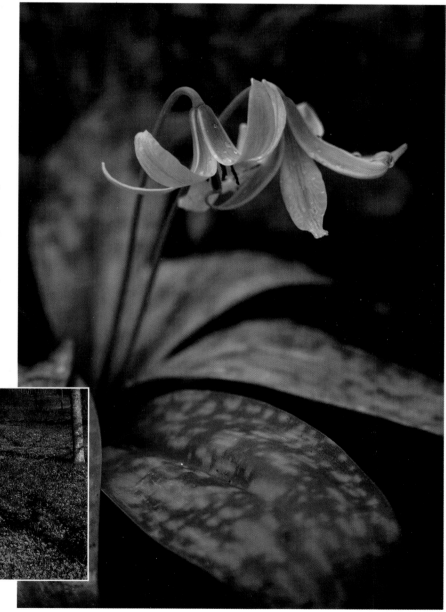

Mayflower
Epigaea repens

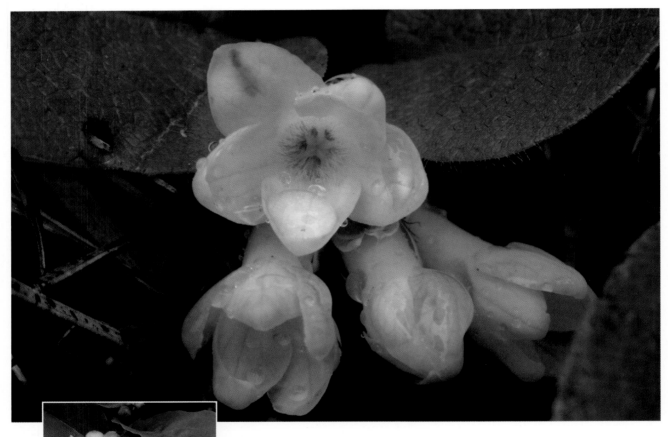

Mayflower (*Epigaea repens*) is commonly found throughout Nova Scotia and New Brunswick, and scattered across Prince Edward Island. Preferred habitat for this woody trailer includes the mossy floor of coniferous woods. Sweetly fragrant pinkish-white flowers appear from mid-April to late May, announcing spring has arrived. The leathery leaves are evergreen.

Nova Scotia designated the Mayflower as the Provincial Floral Emblem in 1901, the first Canadian province to select a botanical representative. While picking Mayflowers is a familiar spring pastime, care should be taken to cut the flowers, rather than pulling the shallow-rooted stems.

Round-lobed Hepatica
Hepatica americana

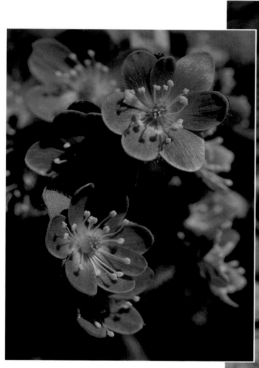

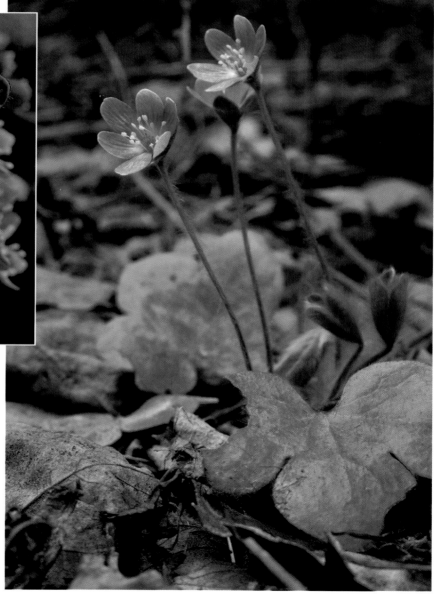

Round-lobed Hepatica (*Hepatica americana*) is a rare herb in New Brunswick and Nova Scotia, and absent from Prince Edward Island. Preferring mixed deciduous forests and slopes, the beautiful flowers mature in April or May. The "petals" are actually sepals, ranging in colour from white to pink to lavender, on stems 10–15 centimetres tall. Below the flowers are green fuzzy leaves with three lobes, which persist after the flowers have set seed.

Spring-beauty
Claytonia caroliniana

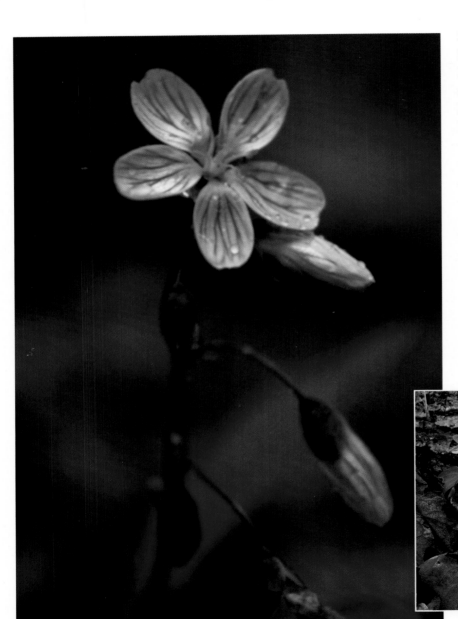

Spring-beauty (*Claytonia caroliniana*) is scattered throughout all three Maritime provinces. This delicate spring wildflower is most common in leaf-mould beneath deciduous trees. Flowers are produced from early May until mid-June. Each plant has only two leaves attached midway along a stem 30 centimetres tall, topped by clusters of white or pink striped flowers. They are similar to Wood-sorrel, which flowers later in summer. However, Spring-beauties have long narrow leaves rather than the three-parted folding leaves of the Wood-sorrel. The Spring-beauty provides a small but tasty tuber buried 7-10 centimetres underground, with a starchy flavour like potatoes.

Little Marybells (Bellwort)
Uvularia sessifolia

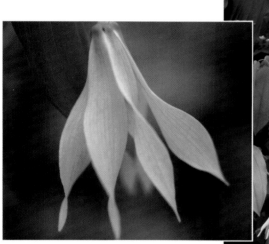

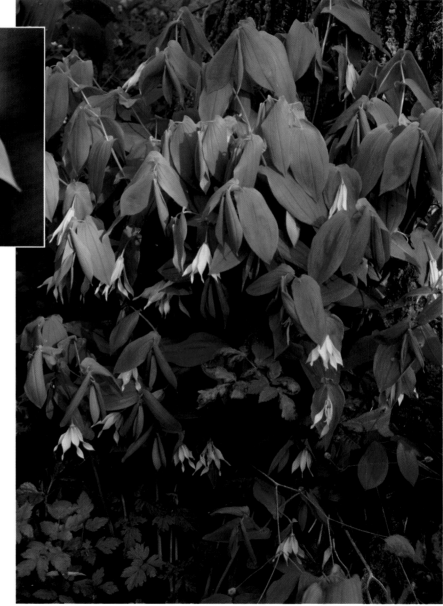

Little Marybells (*Uvularia sessifolia*) is scattered on mainland Nova Scotia, locally common in New Brunswick, and absent from Prince Edward Island. It prefers soils with plenty of moisture and humus, especially in shady broad-leaved forests bordering streams. A few yellow, bell-like flowers nod from the tips of pendulous branches, beneath shiny oval leaves, from April to June, when it is 30 centimetres tall. The relative size of Little Marybells flowers (2–4.5 centimetres long) should distinguish them from the smaller ones of Twisted-stalk or Solomon's Seal, which they resemble. An appetizing vegetable dish may be made from the cooked young shoots, similar in flavour to asparagus.

Rhodora
Rhododendron canadense

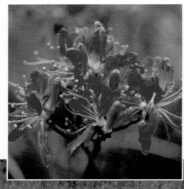

Rhodora (*Rhododendron canadense*) is very common throughout Nova Scotia, Prince Edward Island and southern and eastern New Brunswick, especially in soggy acidic soils. It is most distinctive in May and June when the profusion of rosy purple flowers colour our roadside ditches, swamps and bogs, even before the leaves unfold. The oval leaves are glossy above and have a bluish green cast to their lower surfaces. The wiry shrub, growing to one metre in height, is closely related to our ornamental Azaleas and Rhododendrons.

Jack-in-the-pulpit
Arisaema stewardsonii

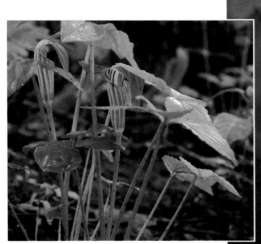

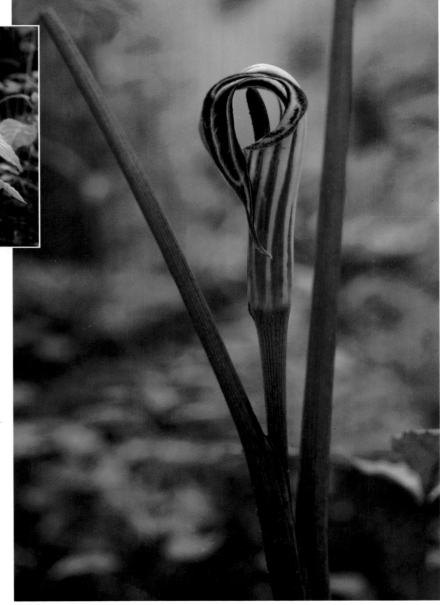

Jack-in-the-pulpit (*Arisaema steward-sonii*) is common in New Brunswick, Nova Scotia and western Prince Edward Island, beneath rich hardwoods in mucky soils along streams, and beneath alders or cedars. Each plant produces a hooded flower from May to July, followed by red berries. The "Jack" is a fleshy, green spike of tiny flowers, surrounded by a purplish, green and white striped "pulpit". Plants may reach one metre. Leaves are divided into threes, which when young, may be mistaken for those of Poison Ivy. Thoroughly dried corms may be ground into a dark flour, but when raw, contain toxic substances such as those in rhubarb leaves.

Yellow Violet

Viola pubescens

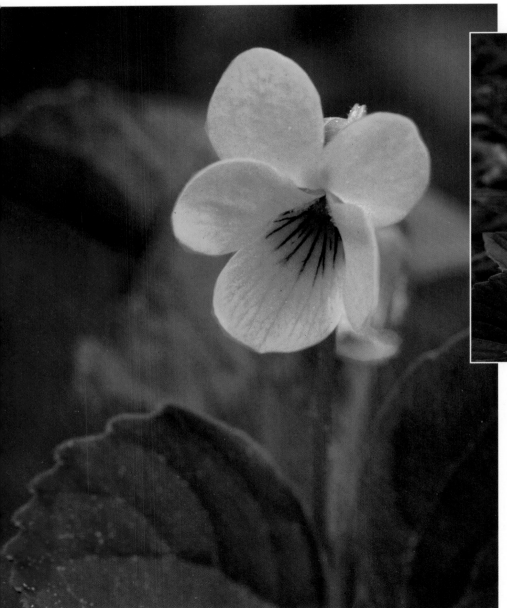

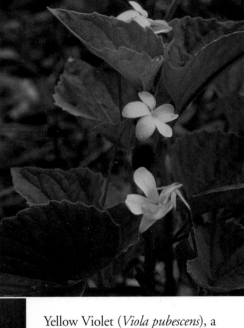

Yellow Violet (*Viola pubescens*), a common inhabitant of New Brunswick, is rare in Prince Edward Island and local in Nova Scotia. Preferring the leaf litter beneath open deciduous forests, these sunny yellow violets bloom in May and June. The flowers rise above the leaves on slender downy stems. The heart-shaped leaves are toothed along their margins. Plants can reach 30 centimetres in height. This is our only yellow-flowered violet.

Purple Violet
Viola cucullata

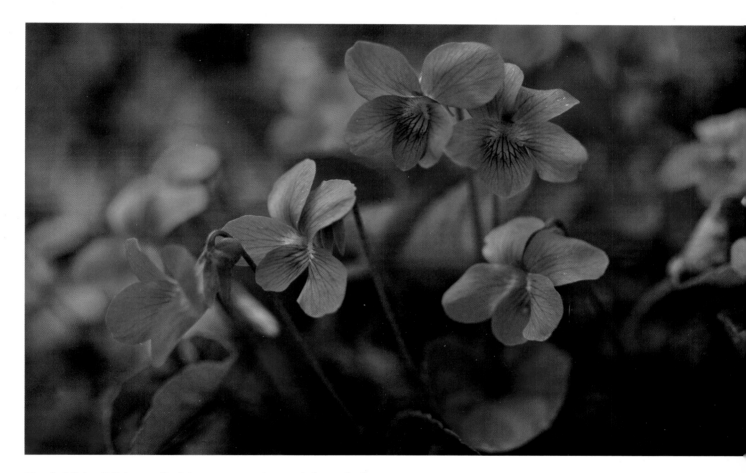

Purple Violet (*Viola cucullata*) is common in the damp soils of New Brunswick, Prince Edward Island and Nova Scotia. Often found in meadows, swamps, bogs and seepy forested areas, it is tolerant of a variety of growing conditions. The fragrant flowers of our most common blue violet appear early May until June, and extend above the leaves to a height of 25 centimetres. The petals are veined towards the centre. The lowest petal is shorter than the lateral ones. Violets make a delightful tea and the fresh flowers may be candied. Since 1936, this species has been the provincial floral emblem of New Brunswick.

Wild Strawberry
Fragaria virginiana

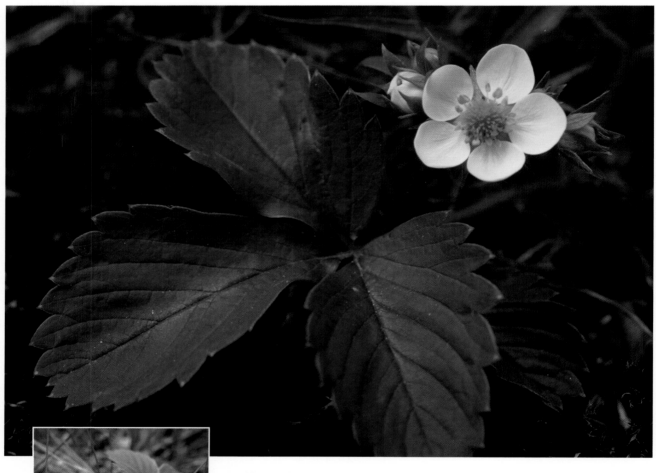

Wild Strawberry (*Fragaria virginiana*) is a common herb throughout Nova Scotia, New Brunswick and Prince Edward Island, particularly in fields, barrens and open mixed forests. The white flowers appear from May to early June, followed by the tiny miniature red fruit familiar to many.

Leaves are divided into three toothed leaflets. Plants spread by seed, but also by runners, along the top of the soil.

The ripened fruit are sweetly delicious, but rarely prolific enough for more than a nibble. Wild Strawberry is one of the parent species of our cultivated Strawberry.

Bloodroot
Sanguinaria canadensis

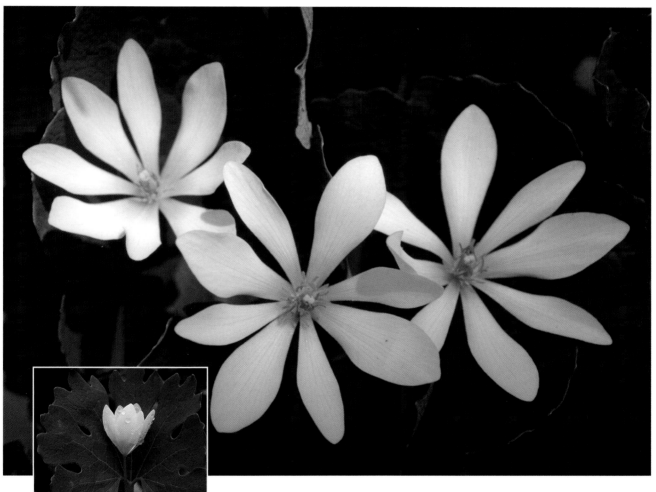

Bloodroot (*Sanguinaria canadensis*) is scattered in New Brunswick and Nova Scotia, but absent from Prince Edward Island. Preferring shade, it inhabits stream-side forests and thickets, often in colonies. One of our earliest wildflowers, its delicate white blooms can appear as early as late April. The attractive leaves are dark green above with whitish undersides and scalloped edges. Plants reach 15 centimetres tall at flowering. Bloodroot takes its name from the acrid red latex present in the roots.

Nodding Trillium
Trillium cernuum

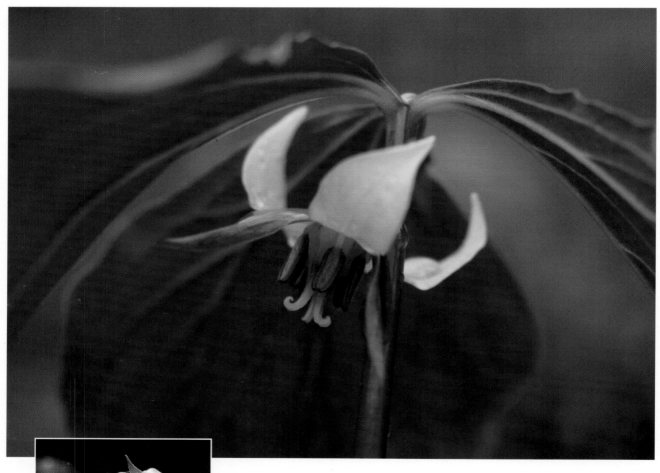

Nodding Trillium (*Trillium cernuum*) is common in northwestern Nova Scotia but absent or rare along the Atlantic shores, uncommon in New Brunswick and scattered throughout Prince Edward Island. It prefers deep soils deposited by streams, or those beneath old-growth deciduous trees.

The pale pink or white flowers develop late May to mid-June, curving downwards beneath the three leaves. Purple Trillium has similar leaves, but its purple flowers grow above them. Both plants range in height from 20–40 centimetres.

Painted Trillium
Trillium undulatum

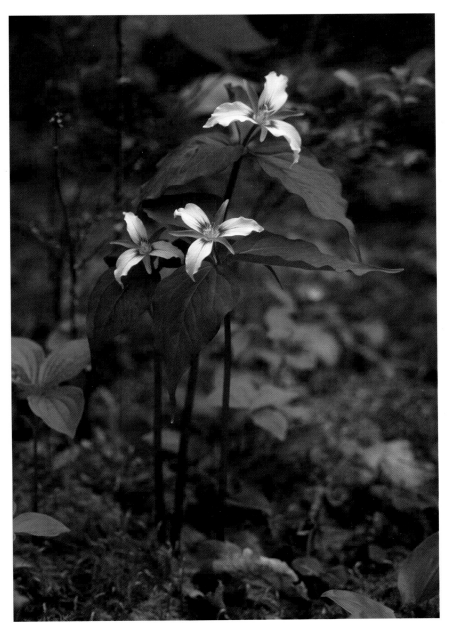

Painted Trillium (*Trillium undulatum*) is scattered throughout mainland Nova Scotia and Prince Edward Island, and common in New Brunswick. It inhabits dry, coniferous forests. The flowers appear mid-May to mid-June. Each of the three white petals have dark pink patches at their centre. The leaves differ from those of other trilliums; they have short stalks attaching them to the stem, and their outline tapers to a long, narrow point at the tip.

Ram's-head Lady's-slipper
Cypripedium arietinum

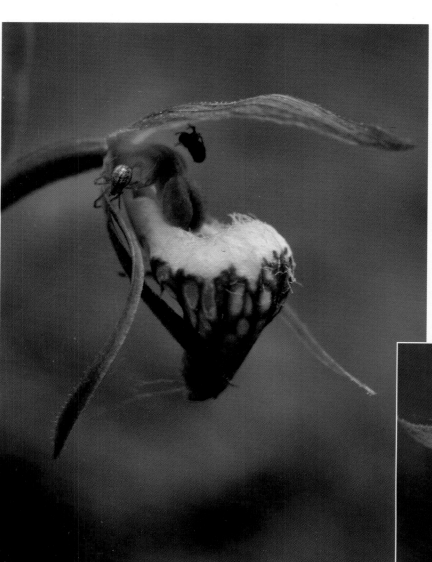

Ram's-head Lady's-slipper (*Cypripedium arietinum*) is very rare, found only in the gypsum soils of forests and outcrops in Hants County, Nova Scotia. Elusive to find, the small rectangular 'slippers' appear during the last week of May. Only one or two flowers are produced at the top of a 40 centimetre tall leafy stem. In profile, the flower resembles the head of a charging ram, hence the English name.

Like other Lady's-slipper orchids, handling the plants may cause a skin rash. Due to their rarity, the Ram's-head Lady's-slipper should be enjoyed, but never picked.

Dutchman's Breeches
Dicentra cucullaria

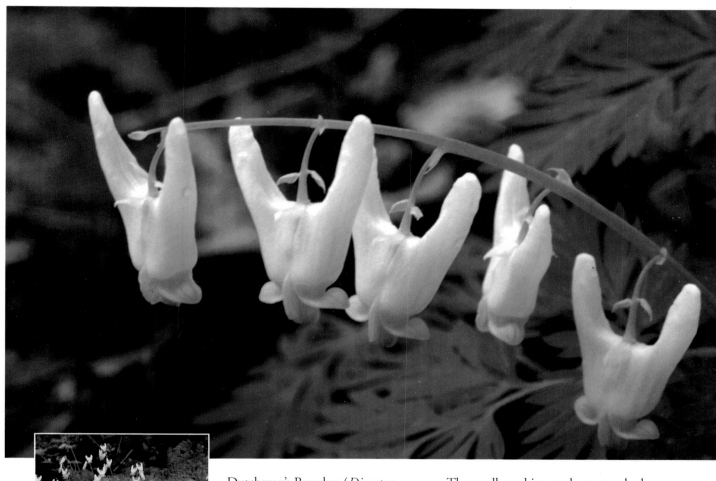

Dutchman's Breeches (*Dicentra cucullaria*) is scattered throughout New Brunswick and Nova Scotia, especially in upland deciduous forests. It seems to be absent in Prince Edward Island. Flowers appear from early May until mid-June, on flowering stems up to 30 centimetres tall.

The swollen white petals are attached to the arching stem by a slender stalk, giving the appearance of tiny pairs of pantaloons on a clothes-line. The light green foliage has a soft, feathery appearance resembling Bleeding-heart, an old-fashioned ornamental to which it is related.

Creeping White Clover
Trifolium repens

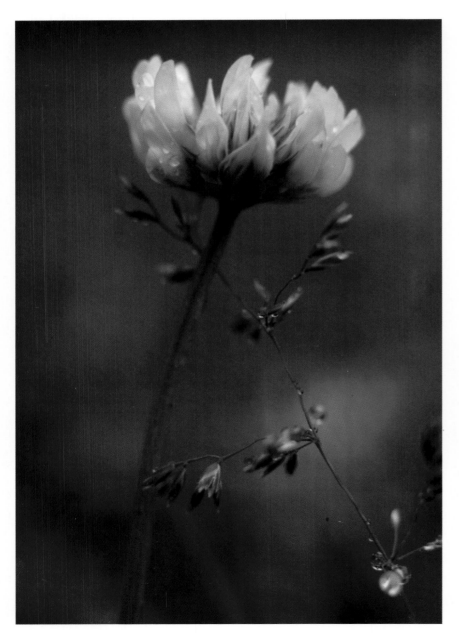

Creeping White Clover (*Trifolium repens*) is common throughout the Maritimes in damp acidic soils on roadsides and in meadows. An annual, its sweetly fragrant flowers are produced from early May to October. Creeping White Clover is our only white-flowered clover species and its leaves have unique pale triangular marks on each of the three leaflets. Teas may be made from a mixture of the dried flower clusters of most clover species, including this widespread plant. Lawn and pasture seed mixtures often include it because of its fast-growing nature.

Yellow Pond-lily
Nuphar variegatum

Yellow Pond-lily (*Nuphar variegatum*) is an aquatic herb that is a common native species of New Brunswick and Nova Scotia, but scattered in Prince Edward Island. Inhabiting still waters of ponds and bog pools, it is rooted in the mucky bottoms, with heart-shaped leaves floating on the water surface. The yellow flowers are large, reaching six centimetres in breadth, appearing from May to September. The leaves may be 20 centimetres long. There are no other similar aquatic species. Apparently, the seeds can be removed from the capsule and popped like popcorn or heated and ground into flour. Its tubers are edible, like potatoes.

Indian Cucumber-root
Medeola virginiana

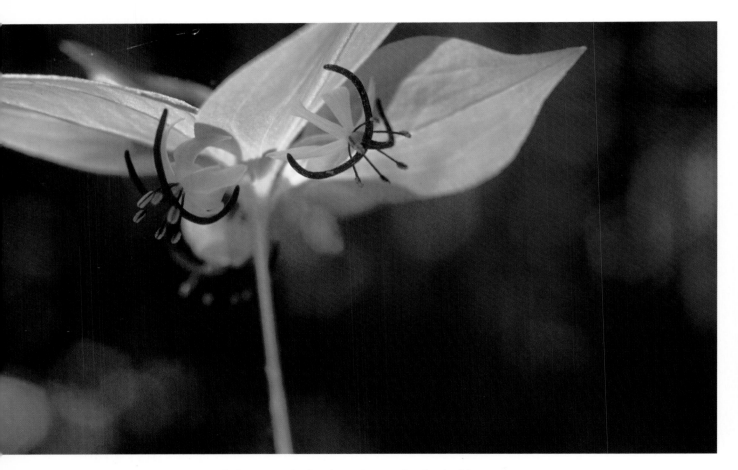

Indian Cucumber-root (*Medeola virginiana*) is scattered to common in all three Maritime provinces, especially in upland mixed or deciduous forests. It is a tall herb growing as high as one metre. The drooping greenish-yellow flowers are produced May and June. Their stamens are reddish in colour. Unlike the trilliums which are of similar height with a single whorl of three leaves, this plant has two whorls, each with up to eight leaves. The flowers are hidden beneath the uppermost leaf cluster. A delicious addition to salads, the tuber tastes like cucumber, a feature it shares with many plants of the lily family.

Bluebead Lily
Clintonia borealis

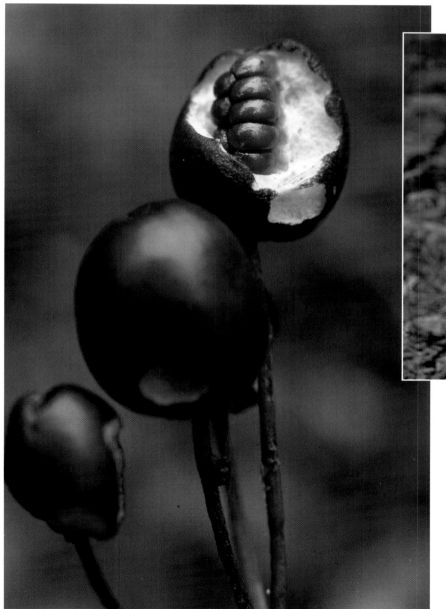

Bluebead Lily (*Clintonia borealis*) is common in mixed conifers and deciduous upland forests in all three Maritime provinces. Forming beds of shining leaves, a leafless stalk as tall as 40 centimetres tall topped by yellow clusters of bell-shaped flowers arises in late May until July. The fruit is an inedible shiny blue berry. However, young unrolled leaves have a flavour reminiscent of cucumbers, raw or cooked.

Purple Trillium
Trillium erectum

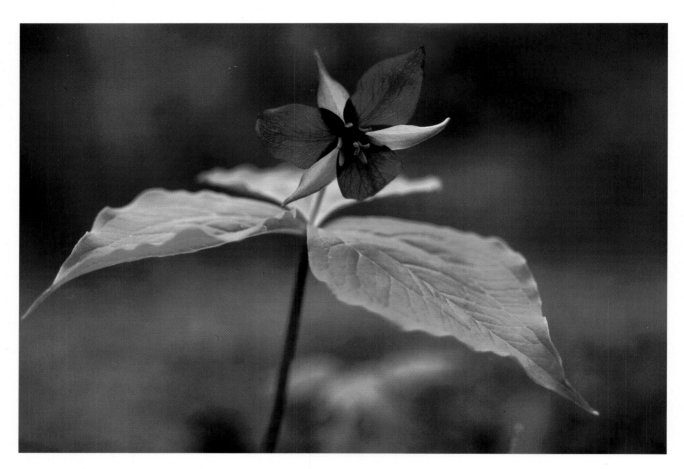

Purple Trillium (*Trillium erectum*) is scattered upon the uplands of New Brunswick and western Nova Scotia. It is not known from Prince Edward Island. Preferring rich soils beneath deciduous forests and often on steep slopes, this trillium presents its flowers during May and June. The beautiful claret blooms have an unpleasant odour. Leaves are diamond-shaped in outline, tapering at both ends, while the leaves of Painted Trillium are rounded where they attach. The flowers of Nodding Trillium are below the leaves, while those of Purple Trillium stand above the leaves. These plants are up to 40 centimetres tall.

Wild Lily-of-the-Valley
Maianthemum canadense

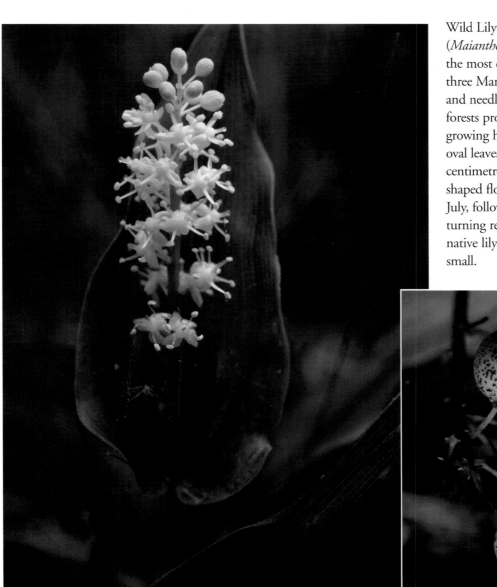

Wild Lily-of-the-Valley (*Maianthemum canadense*) is one of the most common wildflowers in all three Maritime provinces. The mossy and needle-strewn soil of conifer forests provide its habitat. A low-growing herb with two or three shiny oval leaves, this herb barely reaches 15 centimetres in height. The tiny star-shaped flowers are produced May to July, followed by speckled pale berries, turning red mid-summer. No other native lily has four petals or flowers as small.

Seabeach Groundsel
Senecio pseudo-arnica

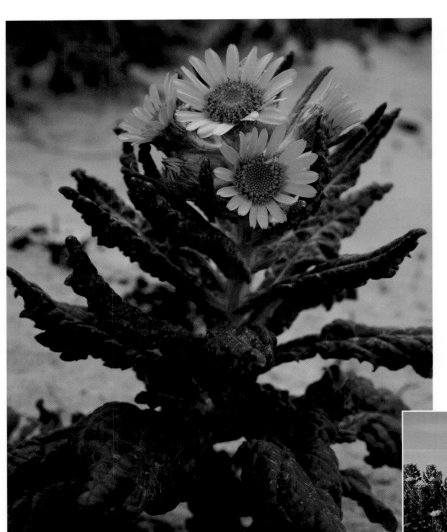

Seabeach Groundsel (*Senecio pseudo-arnica*) is rare in Nova Scotia, very rare in New Brunswick and absent from Prince Edward Island. It inhabits sandy or gravelly beaches, above tide level. Many yellow flower heads are produced, each over 4 centimetres across in early August, followed by seeds with hairlike bristles. Stems are covered with dense hairs and may reach 70 centimetres in height. The leaves are lustrous green above and white woolly on the lower surfaces.

Squawroot
Conopholis americana

Squawroot (*Conopholis americana*) is found in the Maritimes only in Nova Scotia, where it is rare. It is a parasitic plant drawn to trees, often oaks. The hooded yellowish flowers appear in May and June. Instead of leaves, the short brown 20-centimetre stem is covered with yellow-brown fleshy scales. Pine-sap resembles it, but has slender stems, few scales and bell-shaped drooping flowers.

Few of our flowering plants are truly parasites; most manufacture and store food with the help of sunlight. These unusual species, on the other hand, take nourishment from other living plants. They do not need chlorophyll — the green pigment usually required by plants dependent on the sun.

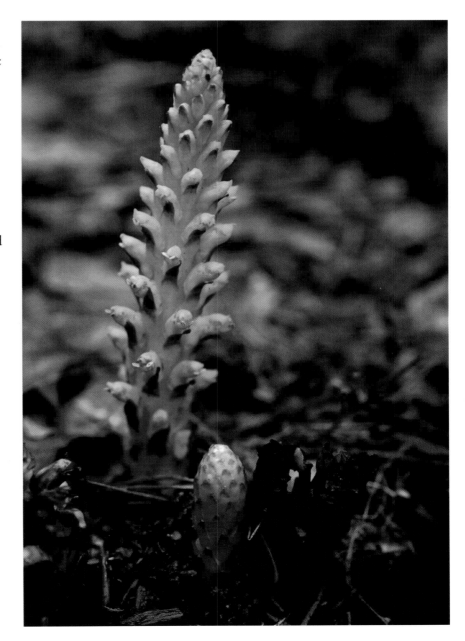

Bittersweet Nightshade
Solanum dulcamara

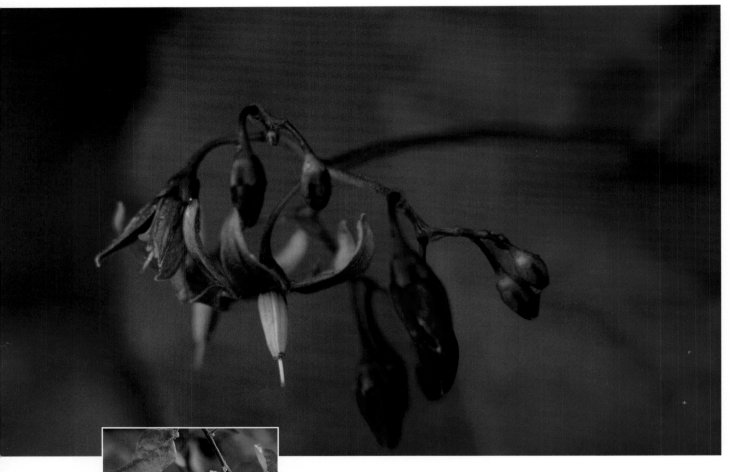

Bittersweet Nightshade (*Solanum dulcamara*) is a common introduction to southern New Brunswick and much of Nova Scotia, but local in Prince Edward Island. It grows in thickets, climbing over shrubs and small trees. Violet flowers are produced June to August, followed by oval, ruby berries. The leaves have two lobes at their bases. If the flowers or fruit look familiar, it is because they are related to the tomato and potato. Like those of the potato, the berries are poisonous, containing the same substance found in unripe or sunburned tubers.

Deptford Pink
Dianthus armeria

Deptford Pink (*Dianthus armeria*) is very local in sandy soils in Nova Scotia, New Brunswick and Prince Edward Island. An introduced garden species from Europe, it is grown for its delightful pink and white petals. The entire plant is slender, reaching 50 centimetres. Flowers appear in June and July. The leaves are paired along the stem and the base of each flower is surrounded by a stiff bract. Our other pink does not have these bracts, nor the white speckles on the petals.

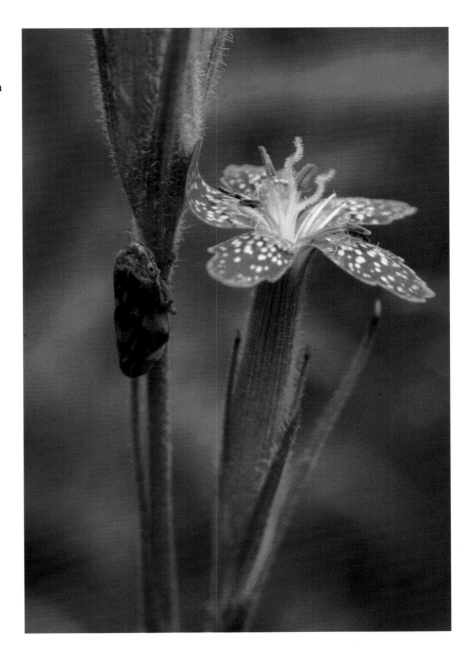

Dragon's-mouth
Arethusa bulbosa

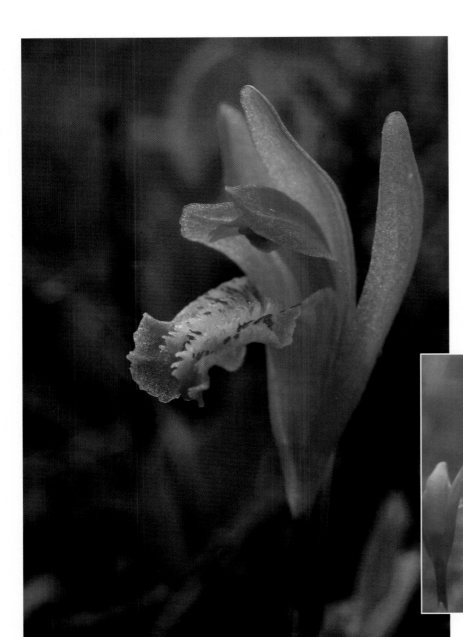

Dragon's-mouth (*Arethusa bulbosa*) is rare in western Prince Edward Island, uncommon throughout New Brunswick and abundant in Nova Scotia. It prefers acidic soils in bogs or sand plains. Standing 25 centimetres tall, a single pink flower is produced in June or July. Two petals are pink while a third is yellow and white spotted with pink and bearded. Behind the petals stands three pink erect sepals. Resembling Grass-pink and Rose Pogonia, this orchid is distinguished by the multicoloured bearded lower petal. Leaves do not appear until seed set, and then only a single grass-like leaf emerges.

Early Summer

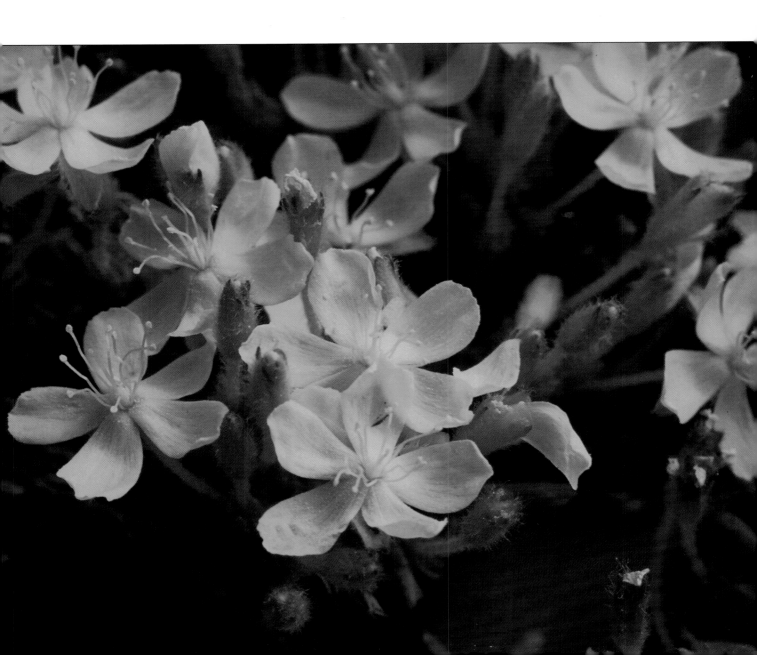

Wild Rosemary

Andromeda glaucophylla

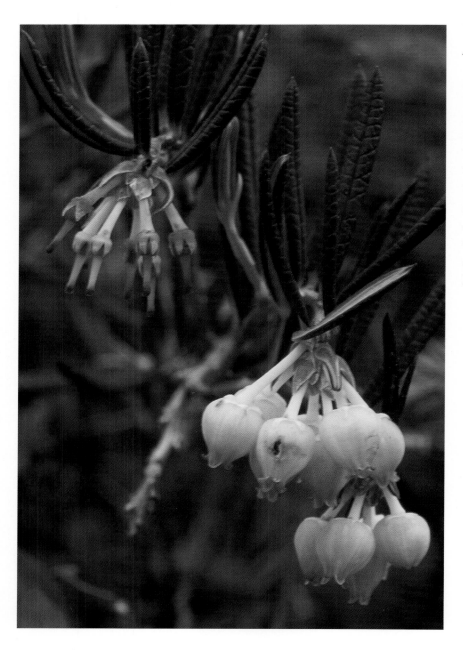

Wild Rosemary (*Andromeda glaucophylla*) is common in peat bogs throughout Nova Scotia, New Brunswick and western Prince Edward Island. These shrubs may be half-buried in the mosses, rarely exceeding 50 centimetres in height. Wild Rosemary flowers in early June. The leathery leaves are distinctive, bluish green and covered with white felt beneath. They are tightly rolled, ending in a sharp point. Although this plant physically looks like the culinary herb rosemary, it does not have aromatic leaves, nor is it edible.

Roseroot

Sedum rosea

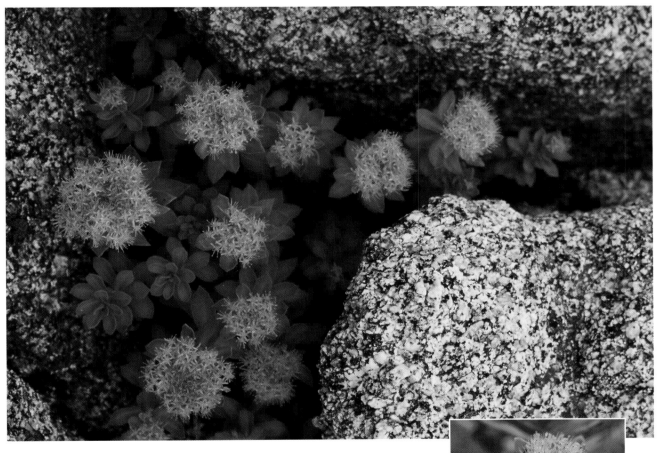

Roseroot (*Sedum rosea*) is common on the coastal cliffs along the Bay of Fundy of Nova Scotia and New Brunswick. It is absent from the Atlantic shores of Nova Scotia and the Gulf shores of Prince Edward Island. Amidst windswept rocks, the tiny crevices with the barest of soils are home to this sturdy species, standing 10–40 centimetres. The stems bear rubbery leaves and are topped by many tiny greenish yellow flowers in June. Roseroot resembles no other species with which it grows. Its succulent nature, like that of desert cacti, serves to prevent moisture loss in such inhospitable environments.

Rosy Twisted-stalk

Streptopus roseus

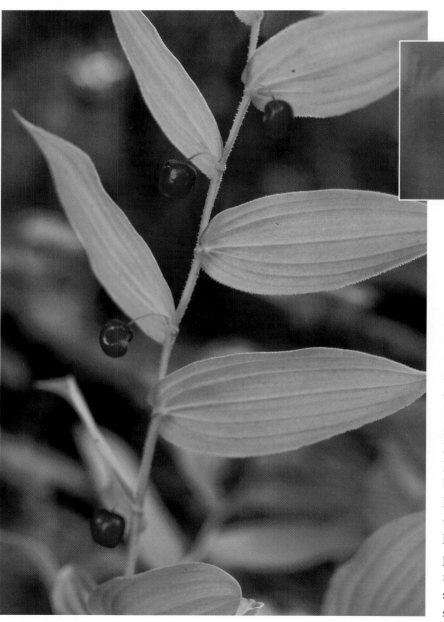

Rosy Twisted-stalk (*Streptopus roseus*) is scattered to common throughout the Maritimes. Preferring acidic soils, it most often frequents coniferous or mixed woods and thickets. Blooming in June, the rose-coloured flowers are pendulous beneath the leaves, from crooked stalks. The light green leaves are carried on the branches at the top of the plant; the lower stem is bare, 30–80 centimetres high. Solomon's Seal has similar leaves, but its flowers are usually in pairs. Green Twisted-stalk has green rather than rose flowers. Young shoots impart a cucumber flavour to salads.

Twin-flower
Linnaea borealis

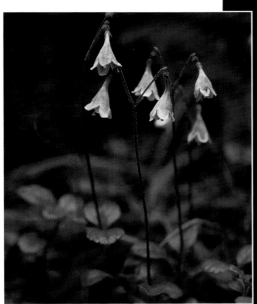

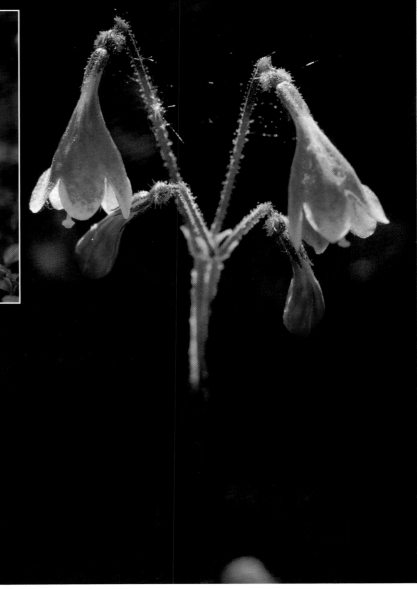

Twin-flower (*Linnaea borealis*), a common inhabitant of all three Maritime provinces, prefers the mossy mounds beneath spruce and fir trees. In June, pairs of delicate pink flowers arise, like fairy bells, on threadlike stems less than ten centimetres high. Plants grow in colonies, their slightly woody stems trail over the ground bearing pairs of leaves with scalloped margins. Partridgeberry also grows beneath conifers, but their leathery green oval leaves have a white vein, and their flowers are not carried in pairs.

Bunchberry
Cornus canadensis

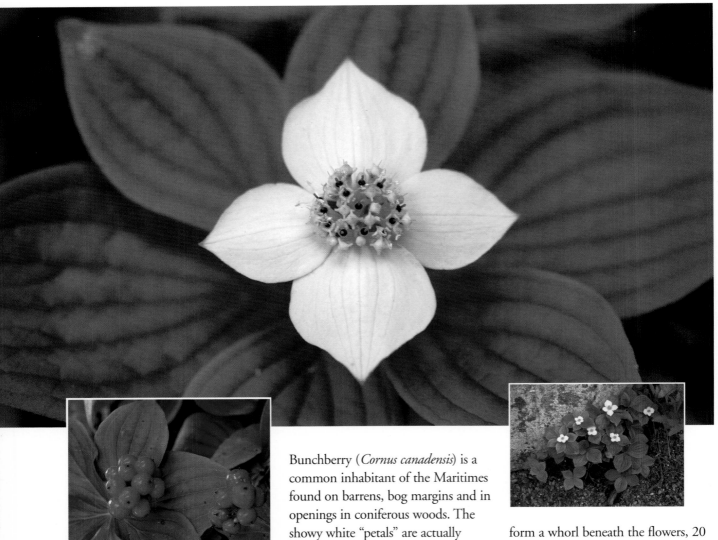

Bunchberry (*Cornus canadensis*) is a common inhabitant of the Maritimes found on barrens, bog margins and in openings in coniferous woods. The showy white "petals" are actually bracts surrounding the tiny green flowers that appear in June. Later, in July, clusters of scarlet berries develop. Leaves usually number four to six and form a whorl beneath the flowers, 20 centimetres tall. Plants tend to form large colonies. The berries, while edible, are rather bland in flavour and not highly prized.

Sheep Laurel
Kalmia angustifolia

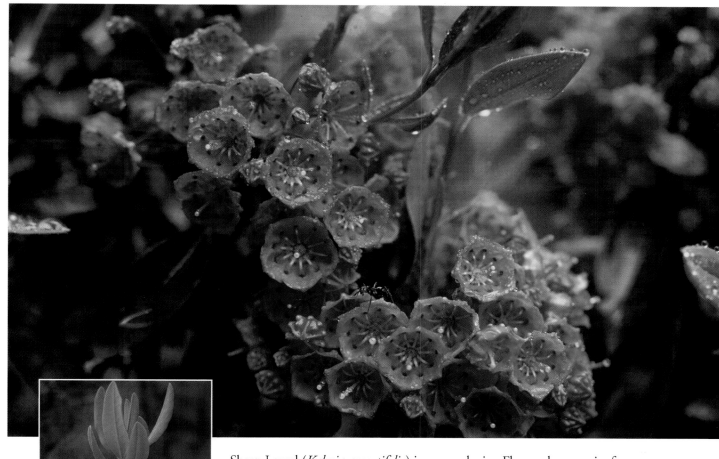

Sheep Laurel (*Kalmia angustifolia*) is abundant throughout the Maritimes, especially in acidic soils. Frequently, it grows in bogs, openings in coniferous forests and in wet thickets. Its bright pink, saucer-shaped flowers appear late June through early July. The erect plants grow up to one metre tall and are shrubby, their branches woody and wiry. Flower clusters arise from the sides of the stems, amidst the leathery leaves. Bog Laurel resembles Sheep Laurel, except that it grows in wetter situations and has pale pink flowers at the tips of its branches. The stems and leaves of Sheep Laurel are toxic to grazing livestock. Some call it Lamb-kill for that reason.

Starry False Solomon's Seal
Smilacina stellata

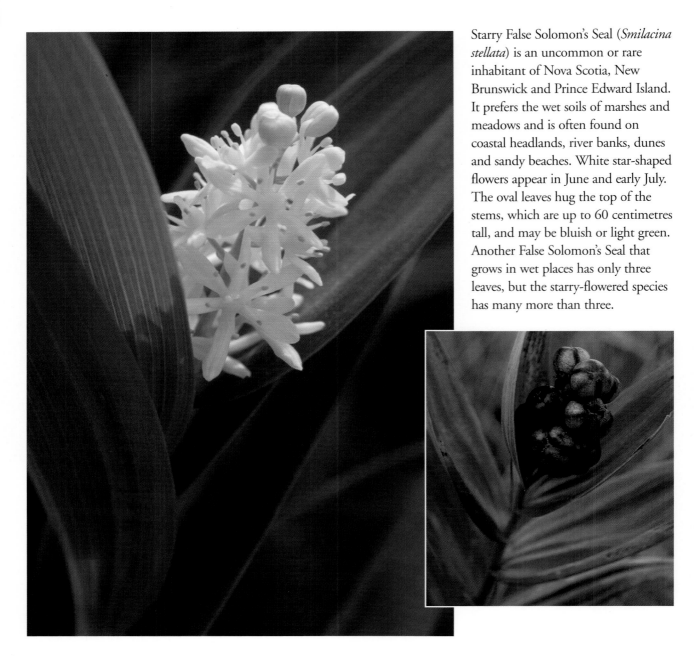

Starry False Solomon's Seal (*Smilacina stellata*) is an uncommon or rare inhabitant of Nova Scotia, New Brunswick and Prince Edward Island. It prefers the wet soils of marshes and meadows and is often found on coastal headlands, river banks, dunes and sandy beaches. White star-shaped flowers appear in June and early July. The oval leaves hug the top of the stems, which are up to 60 centimetres tall, and may be bluish or light green. Another False Solomon's Seal that grows in wet places has only three leaves, but the starry-flowered species has many more than three.

Common Wood-sorrel
Oxalis acetosella

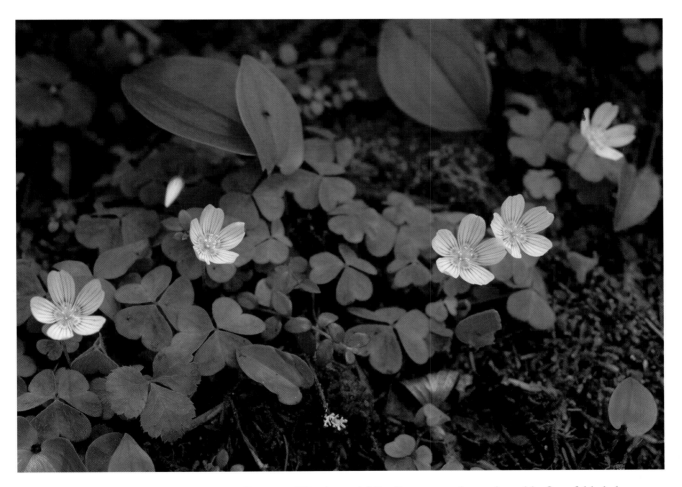

Common Wood-sorrel (*Oxalis ace-tosella*) is common throughout the Maritime provinces, in mossy coniferous woods of spruce and fir. Flowers appear in early June to July, their white petals marked with red or pink lines, on stems as tall as 15 centimetres. The leaves are divided into three heart-shaped leaflets, folded along their centre veins. Similar to Spring-beauty flowers of deciduous woods, the leaves of Wood-sorrel should distinguish it from the long narrow pair of leaves of that species. Adding raw foliage to salads will impart a pleasing sour flavour.

Pitcher Plant

Sarracenia purpurea

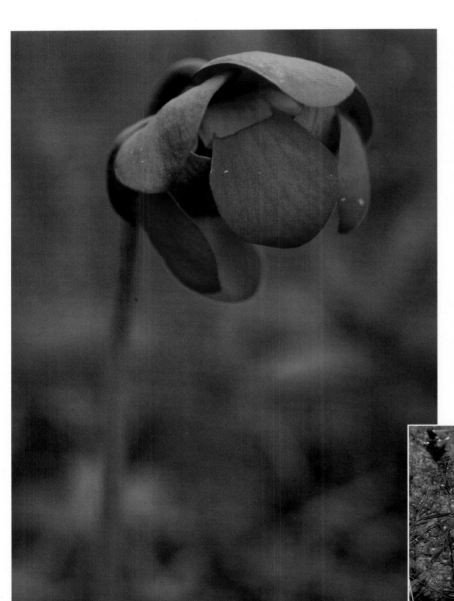

Pitcher Plant (*Sarracenia purpurea*) is common throughout Nova Scotia and New Brunswick, but only scattered in Prince Edward Island. A typical dweller of peat bogs, the highly-visible red flowers appear on 20-25 centimetre stalks in early summer. Most distinctive of the plants are the thick leaves, modified into vases or pitchers, which collect rainwater. If one looks closely, a series of hairs lies on the inner veined surface, all pointing downwards. This armature prevents helpless insects from crawling out of the 'drowning pot'. Their bodies eventually decay, providing nutrients to the Pitcher Plant. No other species resembles this insect-eating plant.

Blue Flag
Iris versicolor

Blue Flag (*Iris versicolor*) is locally common throughout the Maritimes, especially in wet, low-lying areas such as marshes, meadows, pond margins and coastal headlands. The lively blue and white flowers appear in June and July, followed by swollen seed capsules, which persist throughout autumn. The light green leaves are flat and strap-like, sometimes growing 80 centimetres tall. Many relatives are cultivated for ornamental Irises. The rootstocks may be confused with those of Sweet-flag and Cattails, both collected for food. However those of Blue Flag and all other irises are poisonous.

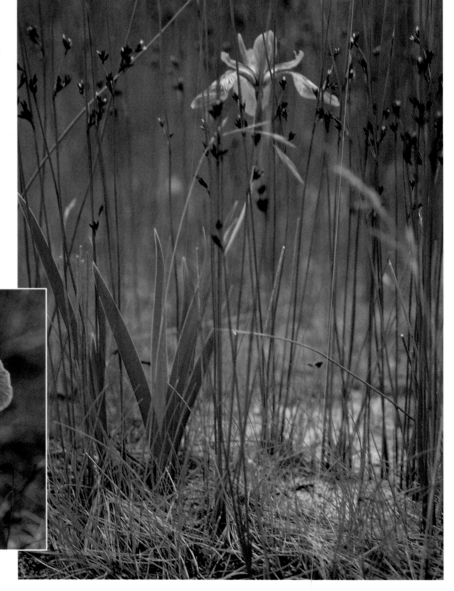

Ragged Robin
Lychnis flos-cuculi

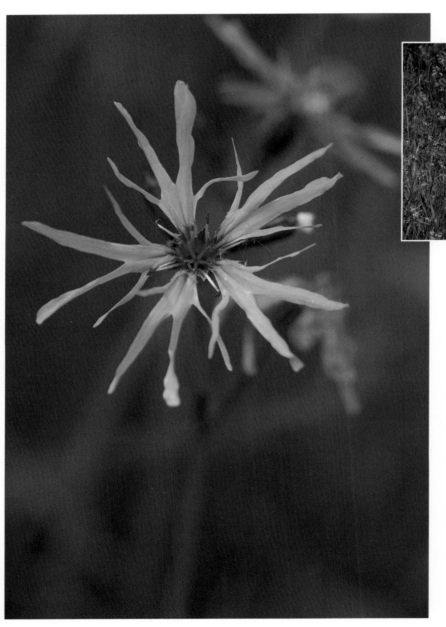

Ragged Robin (*Lychnis flos-cuculi*) is a rare introduction in Nova Scotia and New Brunswick, but is not known from Prince Edward Island. Wet fields and meadows may be coloured pink in June and July, when it blooms in profusion. White-flowered forms are not unusual amidst the plants with pink blooms. The five petals are deeply forked giving the plant its ragged appearance. Leaves are paired opposite each other on the stem, standing 30–80 centimetres tall.

Evening-primrose
Oenothera biennis

Evening-primrose (*Oenothera biennis*) is common throughout Nova Scotia and Prince Edward Island, but uncommon in New Brunswick. Preferring sandy soils, it is found on roadsides, fields, or even the cobbly mounds behind sea beaches. Blooming throughout the summer, its sunny yellow flowers only open during times of low light. A biennial, only leaves are produced the first year. The flowering shoot follows the second year, reaching 0.5–1.5 m.

These plants have recently been found to contain significant amounts of Vitamin E, and fields of commercially grown plants yield the oil prized in pharmaceuticals. Both the young leaves and roots may be cooked and eaten.

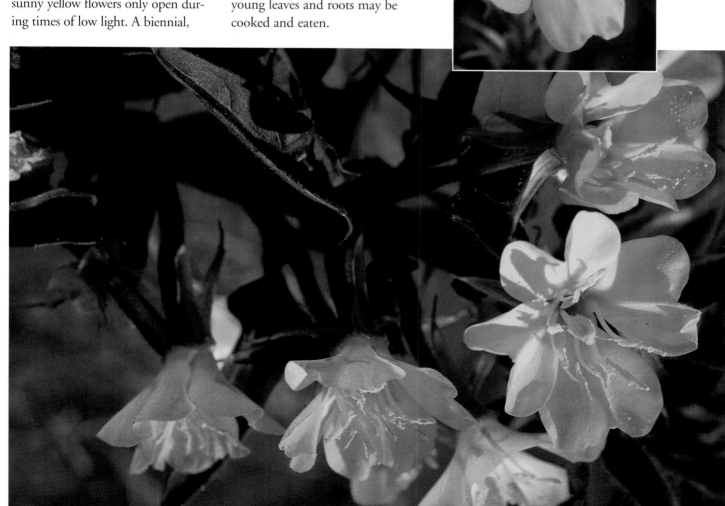

Yellow Lady's-slipper
Cypripedium calceolus

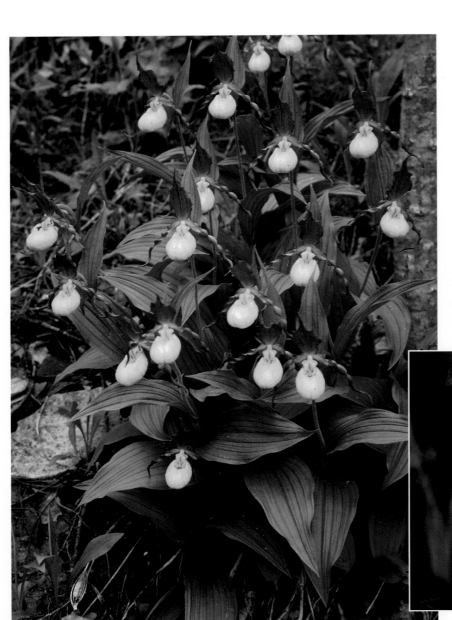

Yellow Lady's-slipper (*Cypripedium calceolus*) is a rare orchid of Prince Edward Island and only slightly more frequent in Nova Scotia and New Brunswick. Inhabiting alkaline soils, it is often found in rich hardwood and cedar wetlands. Each leafy plant bears one or two golden yellow flowers, May to July, on stems up to 80 centimetres tall. The slippers have a round opening which bees enter in search of food.

As with other Lady's-slipper orchids, handling may cause a skin rash. Because these plants are rare, picking should be avoided.

Round-leaved Sundew
Drosera rotundifolia

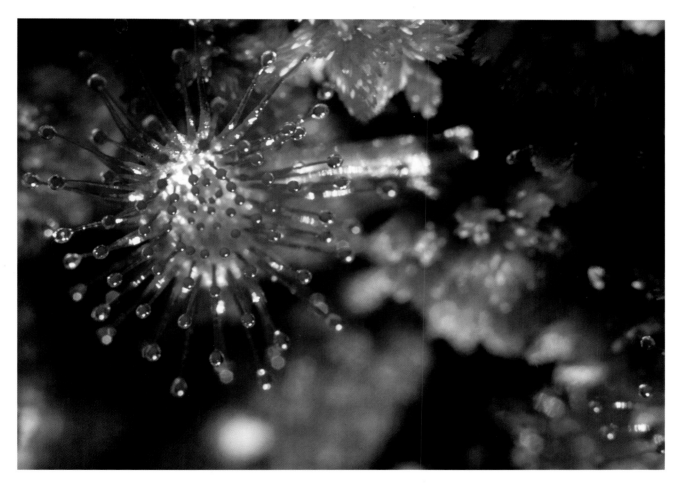

Round-leaved Sundew (*Drosera rotundifolia*) is common throughout Maritime Canada. An inhabitant of acidic soils, sundews are prolific in roadside ditches, swamps, bogs and pond margins. In summer, a slender stalk five centimetre tall arises, bearing a coiled spike of white flowers. The leaves of sundews are unique, covered with hairs bearing a drop of shining glue. Insect visitors become entangled in the sticky mass, and, ever so slowly, the leaf curls around the helpless victim. Eventually the plant digests its prey, absorbing nutrients from it.

Pink Lady's-slipper
Cypripedium acaule

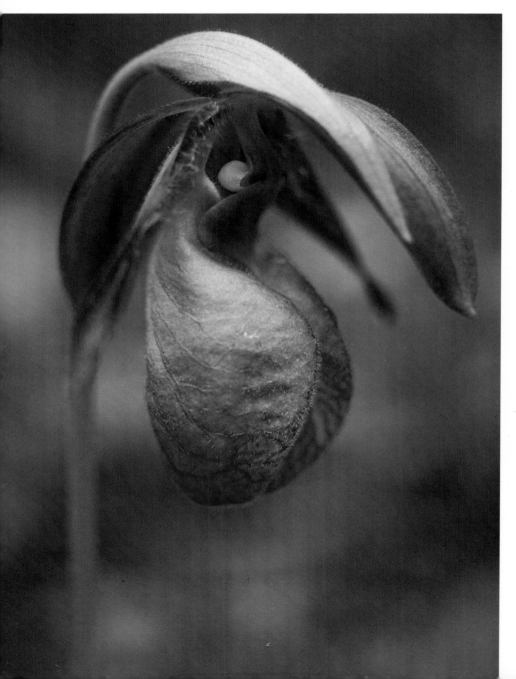

Pink Lady's-slipper (*Cypripedium acaule*) is abundant in Nova Scotia, throughout New Brunswick and in Prince Edward Island, where it is the provincial floral emblem. Found in acid soils in bogs, swamps and damp coniferous forests, this orchid flowers in June. The pink flowers are also called Moccasin-flowers. The pouch is suffused with dark veins and white forms are not uncommon. The other, smaller petals are brownish. Each plant bears a single bloom, reaching 35 centimetres in height. At the base of the flower is a pair of long, oval leaves, with prominent veins. Picking is not encouraged, and those who do so may develop a skin rash from handling them.

Labrador-tea
Ledum groenlandicum

Labrador-tea (*Ledum groenlandicum*) is abundant in all three Maritime provinces, wherever peat bogs and swamps occur. A shrub reaching 90 centimetres, Labrador-tea produces fragrant white flowers in June. The leaves are leathery with the edges rolled under, their lower surfaces covered in rusty or white woolly hairs. The evergreen leaves when dried make a wonderfully mild tea.

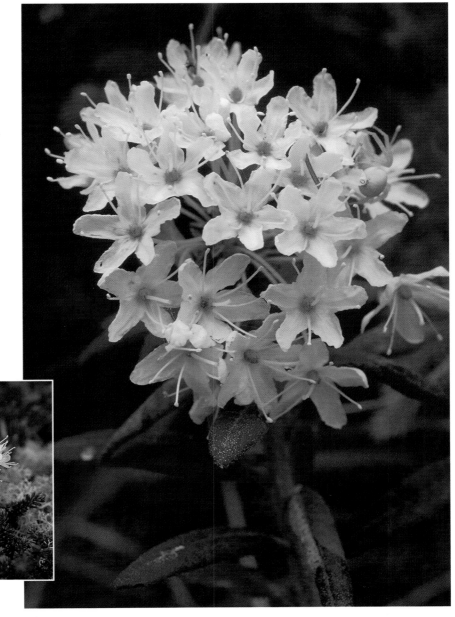

Heath Flower

Hudsonia ericoides

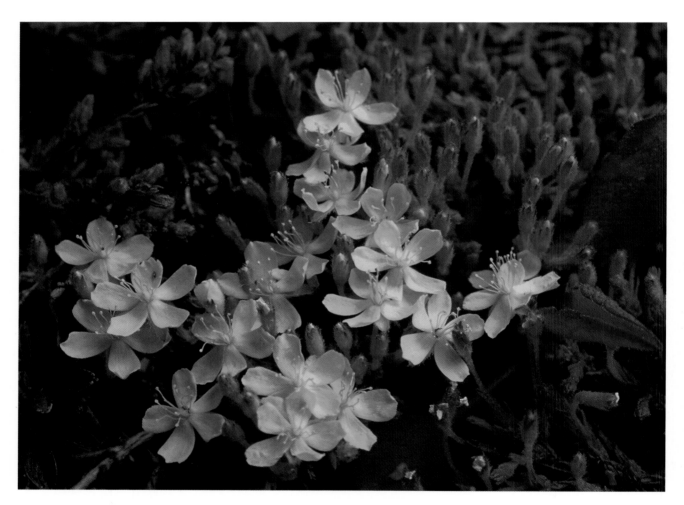

Heath Flower (*Hudsonia ericoides*) is locally abundant on sand barrens of western Nova Scotia and on the sand dunes of eastern Prince Edward Island. Low-growing and forming mats, colonies of this drab evergreen shrub burst forth with golden yellow flowers in June. Resembling Crowberry and Broom-crowberry, the yellow colours should distinguish it from the green or purplish flowers of the other two. Crowberry also produces shiny red or black fruit, while those of Heath Flower are dry capsules.

Fragrant Water-lily
Nymphaea odorata

Fragrant Water-lily (*Nymphaea odorata*) is rare on Prince Edward Island, scattered in New Brunswick, but common in Nova Scotia. With its round floating leaves and sweetly fragrant flowers 12 centimetres across, this aquatic species is highly visible on quiet ponds and lakes between June and September. Yellow Pond-lilies also have floating leaves, but they are heart-shaped and the plants have yellow flowers.

Young plants provide food. The unrolled leaves and flower buds may both be served as boiled vegetables.

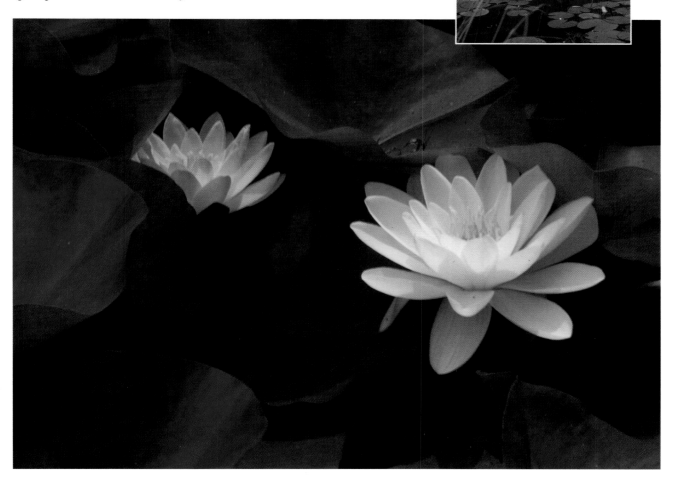

Meadowsweet
Spiraea alba

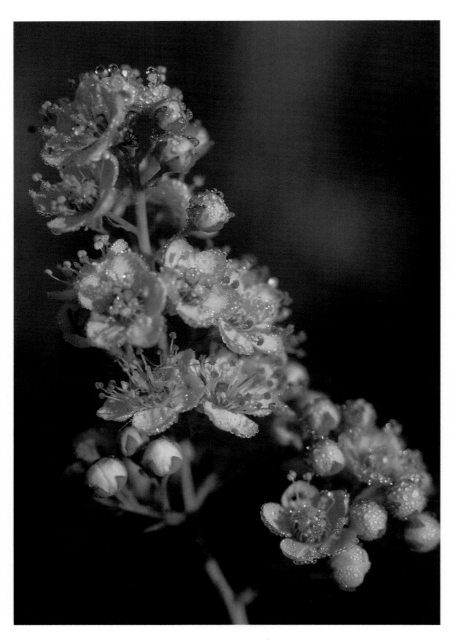

Meadowsweet (*Spiraea alba*) is a common shrub throughout Maritime Canada. Tolerant of a variety of habitats, it frequents roadside banks, ditches, meadows and wetlands. Reddish stems reach heights of 1.5 metres and are topped by clusters of fuzzy pink or white flowers. They flower from June to September. The leaves are oval and coarsely toothed on their edges.

Meadowsweet is closely related to ornamental shrubs sold as 'Bridal Wreath' or Spiraea.

Showy Lady's-slipper
Cypripedium reginae

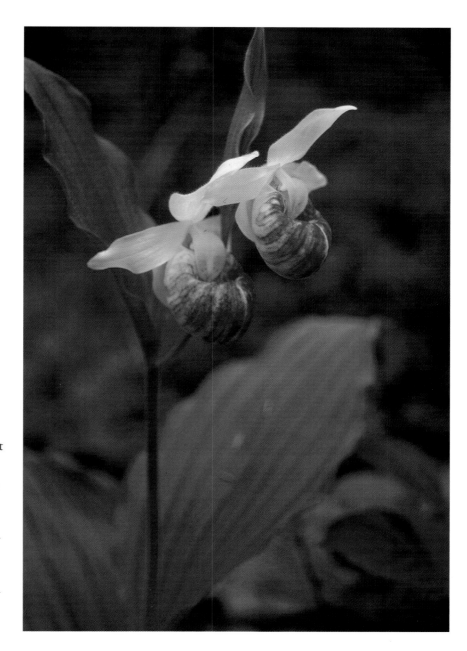

Showy Lady's-slipper (*Cypripedium reginae*) is a rare species in New Brunswick, Nova Scotia and Prince Edward Island. This tall orchid favours mucky soils in larch or cedar thickets, reaching a metre in height at flowering during June or July. The leafy stem carries one or two blooms, each with white petals. The pouch is suffused with rosy pink below the opening. Truly one of our most stunning wildflowers and our largest orchid. It should never be picked or dug. Those who handle it may develop a skin rash, as with other Lady's-slippers.

Bog Laurel
Kalmia polifolia

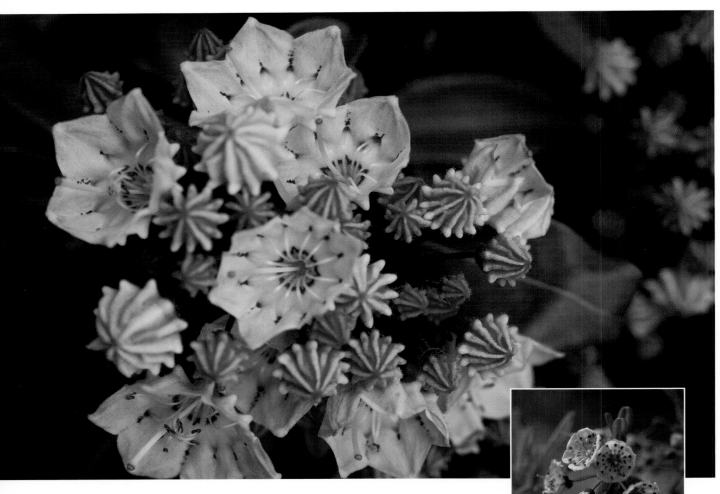

Bog Laurel (*Kalmia polifolia*) is scattered in the lowlands of Prince Edward Island, New Brunswick and Nova Scotia. Limited to peat bogs, the pale pink flowers arise from the ends of branches in June and July. The twigs and stems are ridged, with the stems reaching one metre in height. This shrub shouldn't be confused with Sheep-laurel, a species which is tolerant of drier soils and whose magenta flowers are clustered around the middle of the stem.

Bladder Campion
Silene vulgaris

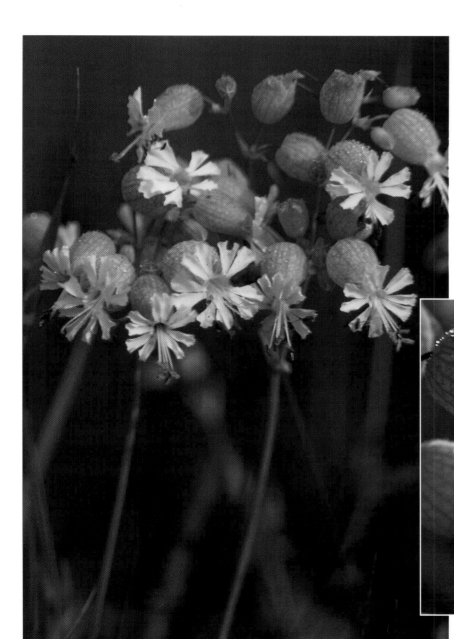

Bladder Campion (*Silene vulgaris*) is a scattered, persistent weed throughout Prince Edward Island, New Brunswick and Nova Scotia, flowering from June to August. It frequents roadsides, fields, urban lots and stream sides, and reaches 50 centimetres in height. Like other campions, the sepals are joined, forming a papery sac beneath the notched petals. Attractive reddish veins mark its surface. Unlike Evening Lychnis, which it resembles, the stems and leaves are smooth, not hairy or sticky.

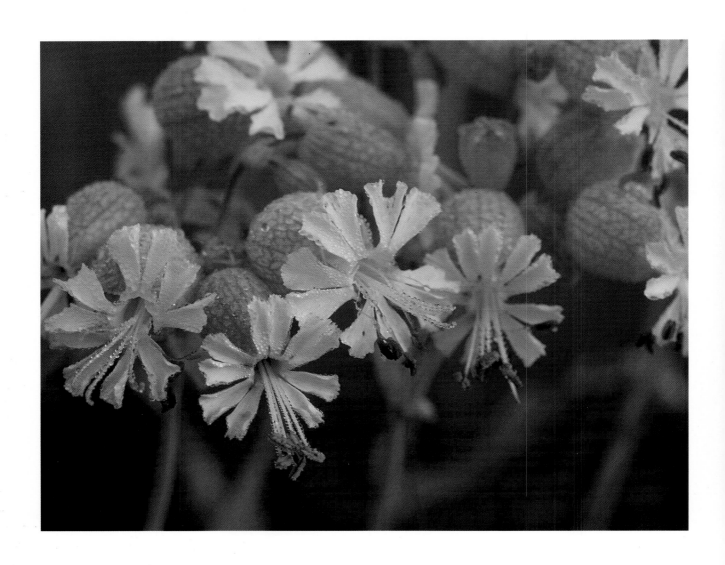

Mid-Summer

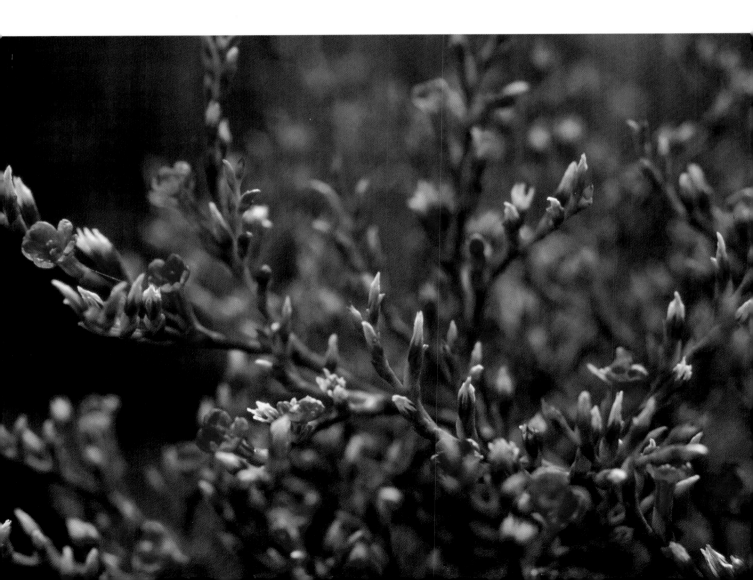

Wild Rose

Rosa virginiana

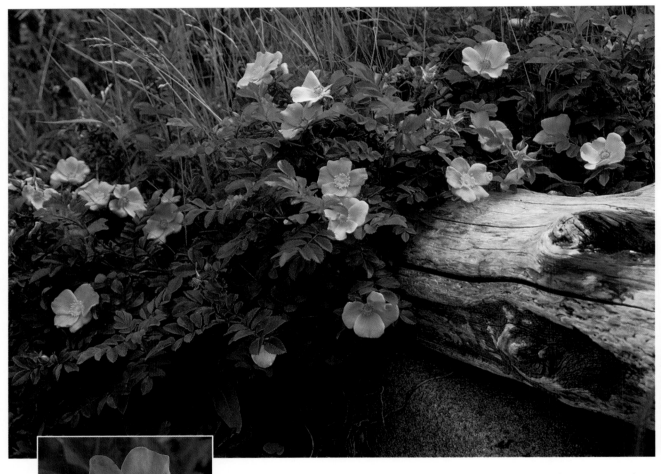

Wild Rose (*Rosa virginiana*) is common throughout Nova Scotia, Prince Edward Island and southeastern New Brunswick. Frequently, it is seen on roadsides, in meadows and thickets with raspberries. The pink, scented roses are produced in July, followed by bristly fruit called rose hips. Shrubs in growth, mature plants may reach 1.5 metres in height and have stout curved thorns along their stems. The leaves are divided into 7–9 leaflets. Often this rose hybridizes with Pasture Rose. Rose hips may be used to make tea or jam.

Bakeapple
Rubus chamaemorus

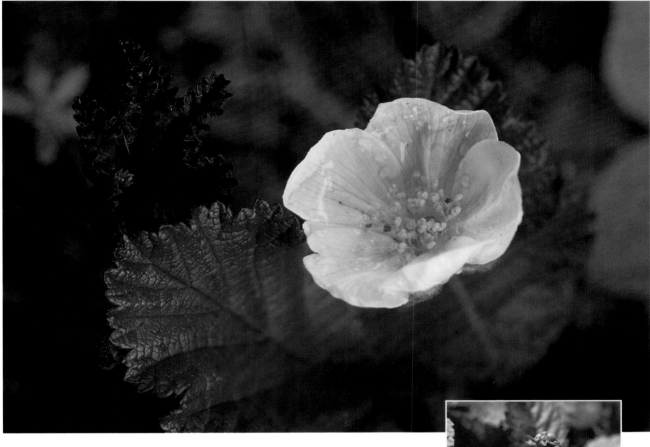

Bakeapple (*Rubus chamaemorus*) is common on all coasts of Nova Scotia, the northwest and southeast coasts of New Brunswick and the western coast of Prince Edward Island, limited to acidic peat bogs. When growing inland, it rarely sets flowers or fruit. On the coast, flowers arise in July, followed by yellow-orange coloured fruit resembling raspberries. Plants rarely reach 15 centimetres in height, tending to be partly buried in the mosses. Leaves are coarse and leathery, but without prickles or bristles. The fruit is highly prized for its unique flavour and large quantities are picked, especially along the Atlantic coast.

Indian Pipe
Monotropa uniflora

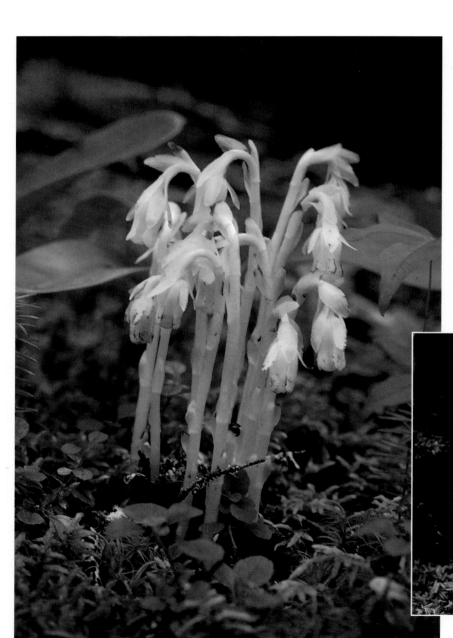

Indian Pipe (*Monotropa uniflora*) is a common native of New Brunswick, Nova Scotia and Prince Edward Island. Tolerating deep shade, it grows amidst leaf litter or decaying needles beneath conifers or broad-leaved trees. Its single nodding flower arises through July and August, on a stem 20 centimetres tall. A ghostly plant, containing no green pigment and no leaves, Indian Pipe is pure white. That changes after it sets seeds, when the stem and flower turn black, drying upright. It resembles Pine-sap, to which it is related, but the single flower should distinguish Indian Pipe.

Lupin
Lupinus polyphyllus

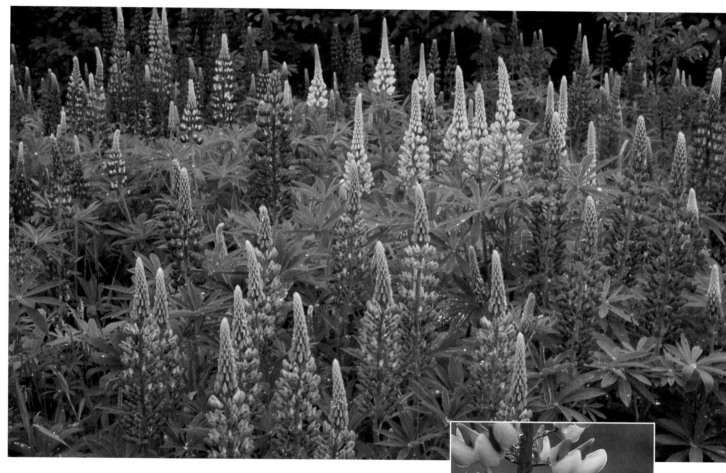

Lupin (*Lupinus polyphyllus*) is a common escape from cultivation in Nova Scotia, New Brunswick and eastern Prince Edward Island. Roadsides, dry fields and meadows provide suitable homes for this western introduction. Reaching nearly a metre in height, the colourful spikes of purple, blue, pink or yellow pealike flowers are produced during June and early July. The foliage is made from attractive whorls of leaves which do not wet with rain. Instead droplets glisten like pearls. The seeds and leaves are toxic, so care should be taken with children and animals.

Beach Pea
Lathyrus maritima

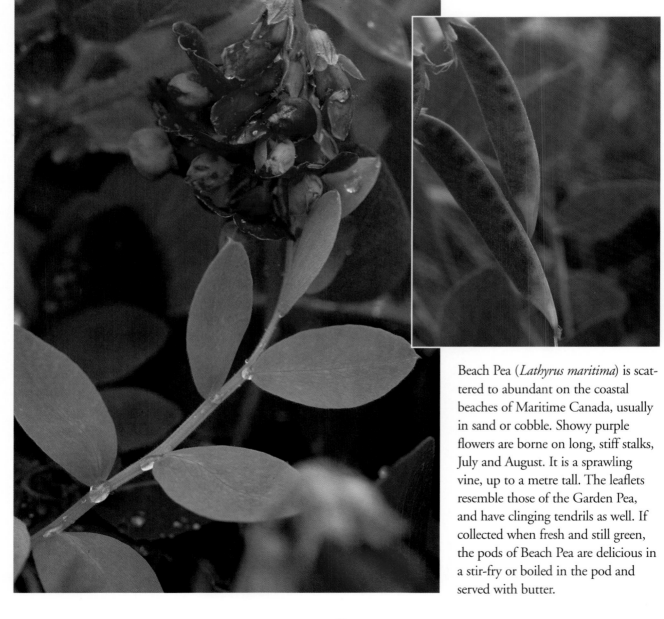

Beach Pea (*Lathyrus maritima*) is scattered to abundant on the coastal beaches of Maritime Canada, usually in sand or cobble. Showy purple flowers are borne on long, stiff stalks, July and August. It is a sprawling vine, up to a metre tall. The leaflets resemble those of the Garden Pea, and have clinging tendrils as well. If collected when fresh and still green, the pods of Beach Pea are delicious in a stir-fry or boiled in the pod and served with butter.

Evening Lychnis
Silene latifolia

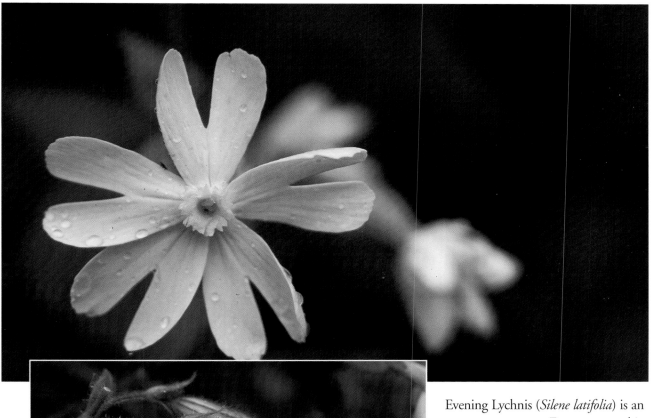

Evening Lychnis (*Silene latifolia*) is an uncommon or rare European weed in Nova Scotia, New Brunswick and Prince Edward Island. Its notched white flowers appear from July to September, on stems 30–60 centimetres tall. The entire plant is covered with sticky, dark hairs, distinguishing it from Bladder Campion. Evening Lychnis also has a papery ridged sac beneath the petals, formed from the united sepals.

Vetch
Vicia sp.

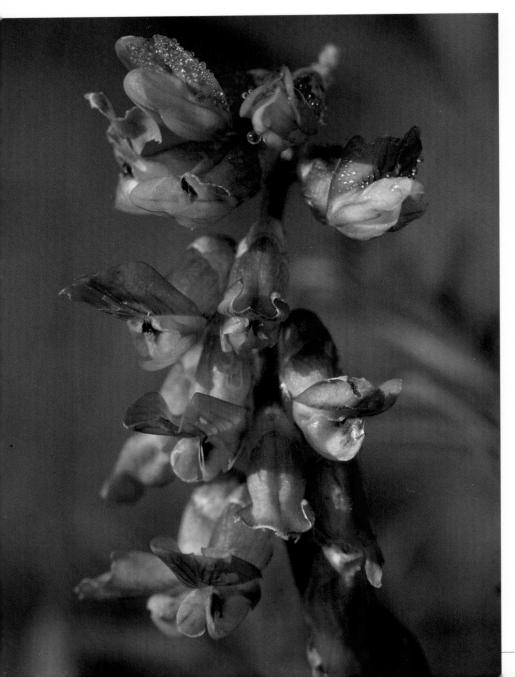

Vetch (*Vicia sp.*) is frequently found in all three Maritime provinces. An inhabitant of dry soils in cultivated fields, along roadsides and dykelands, its small purplish flowers are produced throughout the summer. Small dry, brown pods develop late summer. This vine has weak stems that entangle neighbouring plants. The leaflet at the top of the stem is modified into a tendril, much like that of the garden pea, to which it is closely related.

Pine-sap
Monotropa hypopithys

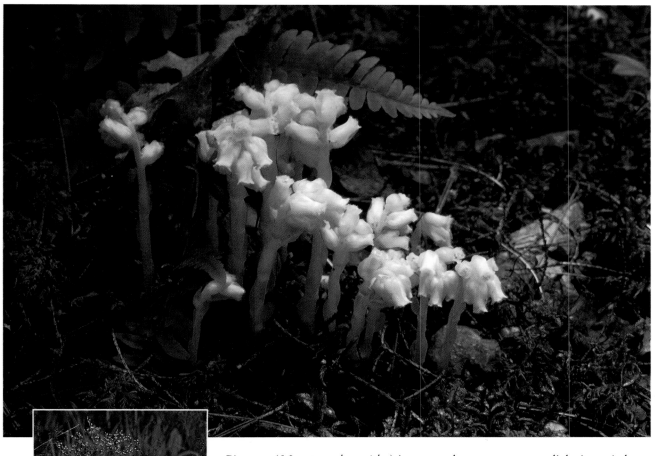

Pine-sap (*Monotropa hypopithys*) is found throughout the spruce and pine forests of Nova Scotia and Prince Edward Island, but is an uncommon native of New Brunswick. Summer-flowering, several yellowish blooms nod from atop a leafless stem, 10–30 centimetres tall. The entire plant lacks the green pigment that enables the plant to convert sunlight into vital food. Instead, these herbs thrive on decaying plant matter or live as parasites on the roots of trees. The species has, over time, lost all its green colour. The yellow colour and multiple flowers should separate it from the single ghostly white Indian Pipe flower which it resembles.

Arrowhead
Sagittaria latifolia

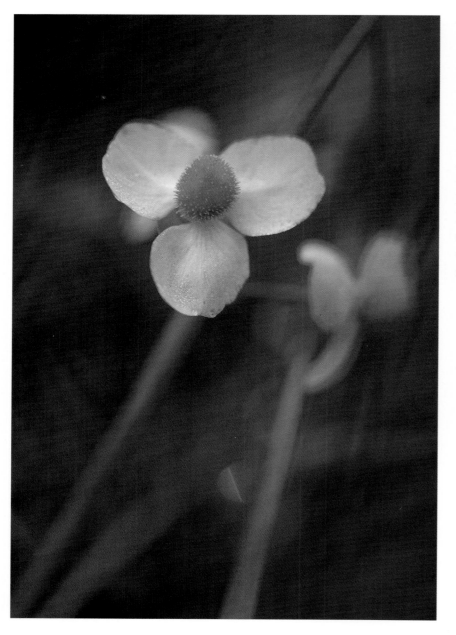

Arrowhead (*Sagittaria latifolia*) is a scattered to common native of Nova Scotia, New Brunswick, and Prince Edward Island. Growing on the mucky margins of ponds, rivers and lakes to more than a metre tall, it may even be partly submerged when water levels are high. The erect flowering stems bear white blooms throughout the summer. Arrowhead takes its English name from the outline of the leaves, which resemble the head of an arrow. The tubers may be raked or dug, and if cooked, their flavour resembles that of potatoes.

Sea-lavender
Limonium carolinianum

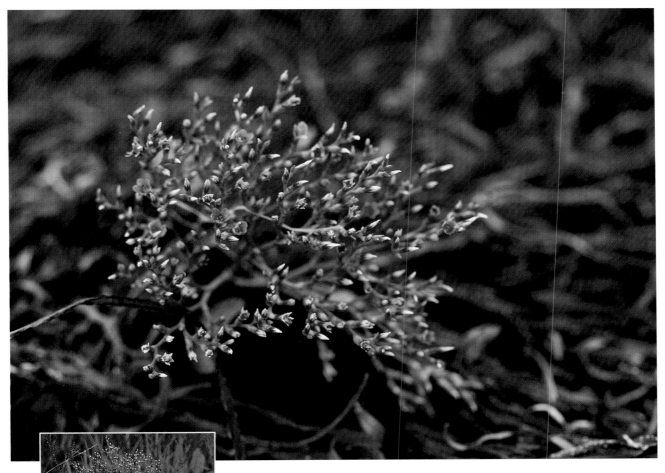

Sea-lavender (*Limonium carolinianum*) is a frequent dweller of coastal New Brunswick, Nova Scotia, and Prince Edward Island. Limited to salt marshes, they are highly visible when delicate sprays of papery, purple flowers are produced, from July to September. During this time, the plants are about 70 centimetres tall. There are two or three pairs of opposite leaves. Ever popular in dried flower arrangements, the tiny flowers retain their colour in a fashion similar to the Garden Statice, a European species to which it is related.

Glasswort
Salicornia europaea

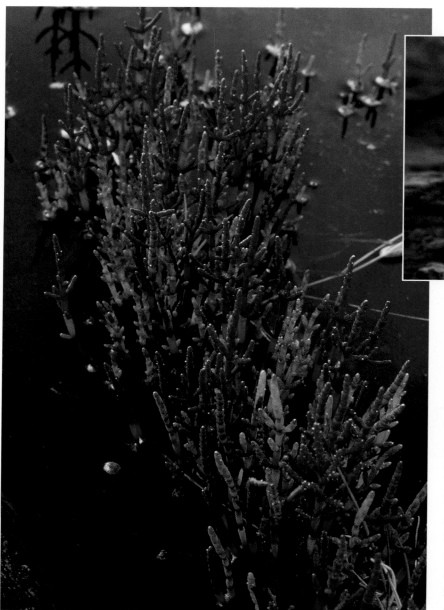

Glasswort (*Salicornia europaea*) is common on the coasts of New Brunswick, Nova Scotia and Prince Edward Island. Limited for the most part to salt marshes, this small herb, up to 50 centimetres tall, may appear weedy where it colonizes bare soil. The entire plant is succulent. Its microscopic flowers are carried in small pits on specialized branches. The leaves are also highly reduced. Light green in colour for most of the summer, Glasswort has a tendency to turn bright red in autumn, giving rise to another English name — Samphire — a corruption of sand fire. The plants give a pleasant texture and mild, salty flavour to salads.

Greenland Sandwort
Minuartia groenlandica

Greenland Sandwort (*Minuartia groenlandica*) is known only from Nova Scotia, where it is rarely seen on windswept rocky barrens in the south-central counties. It favours granite rocks, and roots in tiny cracks with reindeer moss and other lichens. Clusters of small white flowers are visible throughout the summer, from June until late October, despite being rarely more than eight centimetres in height. The leaves are very small and narrow on the stem, with tiny clusters of slightly larger ones at the base of the plant.

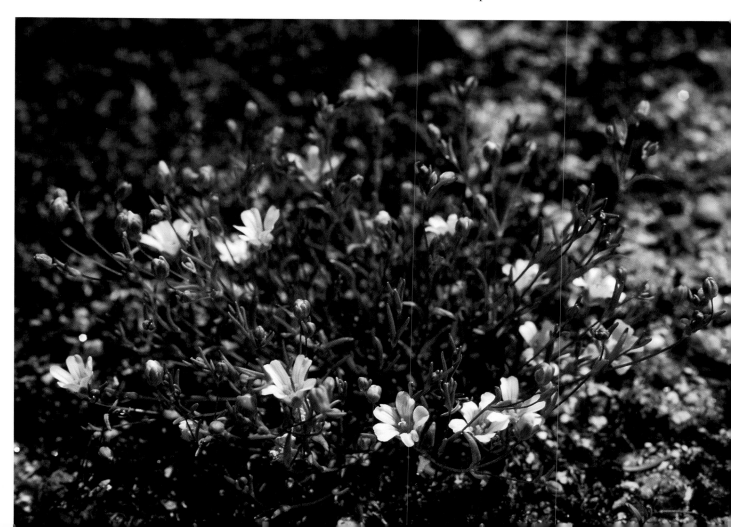

One-flowered Cancer-root
Orobanche uniflora

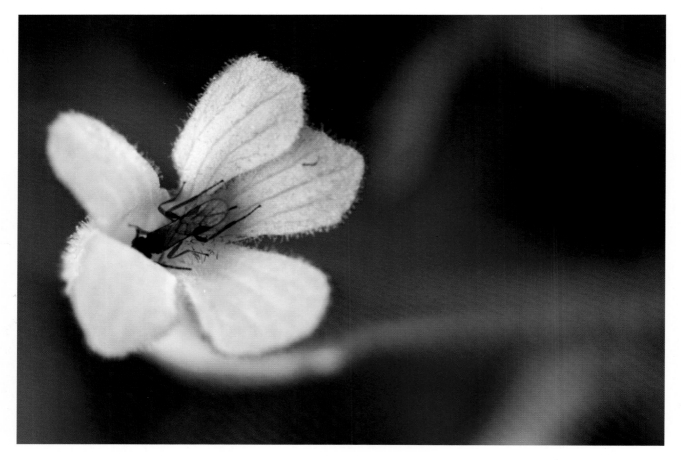

One-flowered Cancer-root (*Orobanche uniflora*) is an uncommon or rare inhabitant of grassy meadows and shady banks in Nova Scotia, southern New Brunswick and southern Prince Edward Island. Blooming in late spring and early summer, the white petals are marked with dull lines. These guide the insect visitors to nectar contained deep within. A striking feature of the species is the lack of leaves. Cancer-root is a parasite, deriving food from other plants. Therefore it requires no green pigment and its leaves are reduced to brownish scales along the stem, which stands 30 centimetres tall.

Groundnut
Apios americana

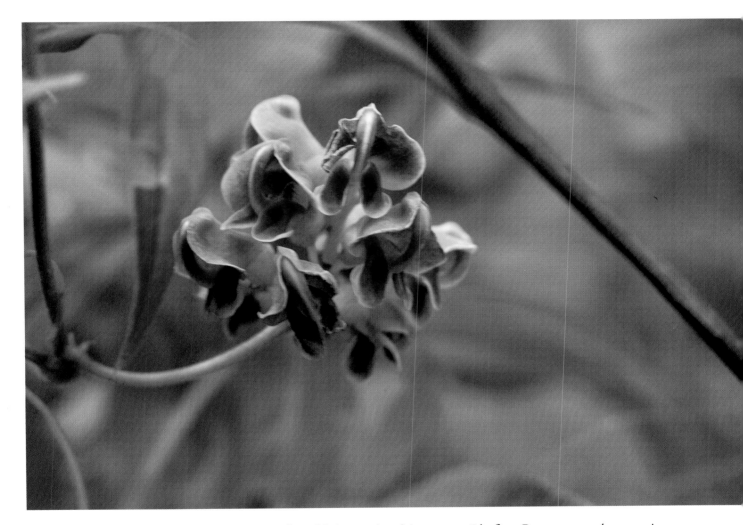

Groundnut (*Apios americana*) is scattered in Nova Scotia and southern New Brunswick on forested stream and river banks, gravel bars and thickets. A colonial vine, it forms pure beds in shady damp soil. There are 5-7 leaflets. Brown or purple aromatic flowers arise from the junction of stem and leaf, from July to October. Groundnut has a root in the form of a series of potato-like tubers, which when cooked, tastes like turnip.

Orange Hawkweed

Hieracium aurantiacum

Orange Hawkweed (*Hieracium auran-tiacum*) is abundant in the uplands of all three Maritime provinces. Preferring dry, grassy areas, this wild-flower peppers lawns, fields, and old pastures with its bold orange flower heads from June to September. The 60-centimetre stems are leafless and covered with coarse dark hairs. Likewise, the leaves at the base of the plant are also hairy. There are 15 species of hawkweeds in our region, but this is the only orange-flowered one, sometimes called Devil's Paintbrush.

Swamp-candles
Lysimachia terrestris

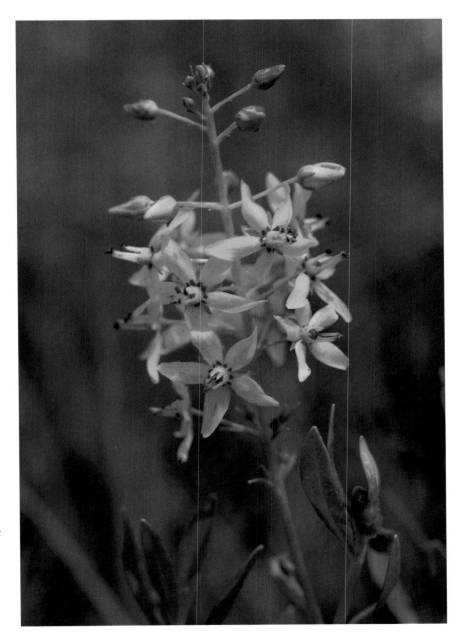

Swamp-candles (*Lysimachia terrestris*), a common inhabitant of all three Maritime provinces, prefers the mucky soil of swamps, bogs, shores and marshes. The bushy spikes of yellow flowers provide display throughout the summer, from June to September. Close examination shows each flower to be shaped like a star, sporting a circle of red spots upon the petals. The leaves are opposite each other along the stem, which ranges from 40–80 centimetres tall. Several closely related species are planted as garden ornamentals.

Ox-eye Daisy

Chrysanthemum leucanthemum

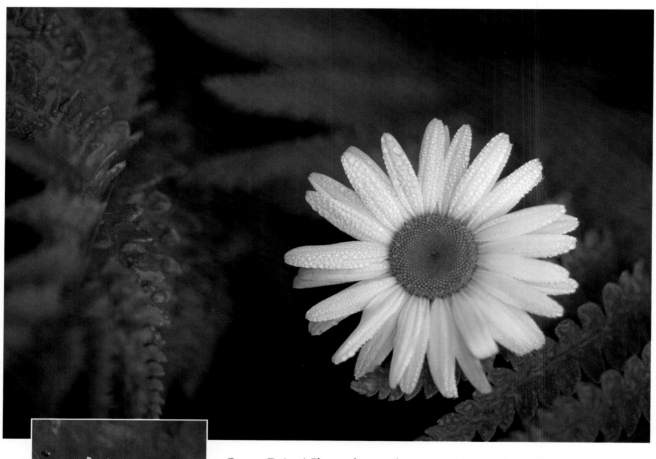

Ox-eye Daisy (*Chrysanthemum leucanthemum*) is a familiar summer wildflower to most, abundant in all Maritime provinces. Its composite flower heads of golden yellow disks surrounded by white rays liven fields, meadows and dry ditches, from June to August. Reaching one metre in height, the stem has scattered leaves with irregular outlines. These herbs are biennial. The first year plants produce only a small clump of leaves just above the ground. The following year flowers arise. Our daisy is an introduction from Europe and a great many of its relatives are cultivated as annuals, perennials or potted plants.

Bindweed
Calystegia sepium

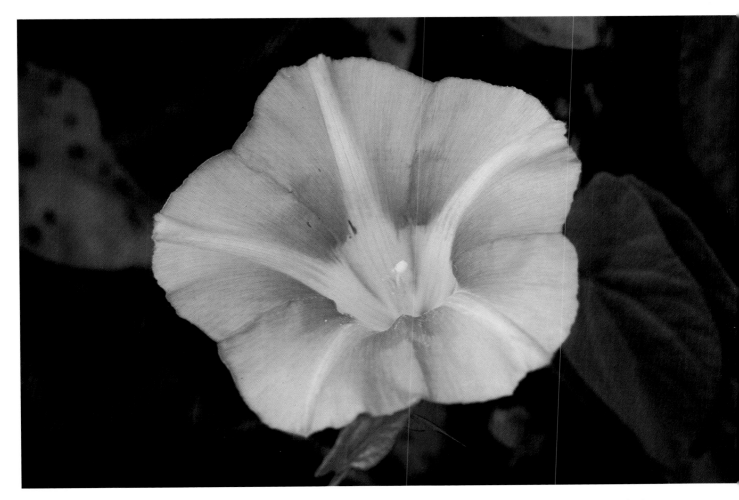

Bindweed (*Calystegia sepium*) is a common vine in Nova Scotia, New Brunswick and Prince Edward Island. Clamouring over other vegetation, it is frequently associated with asters and goldenrods on beaches, in thickets and along rail embankments and roadside ditches. The pink and white bell-shaped flowers are produced from June to September. The leaves are arrowhead-shaped and may be distinguished from those of Field Bindweed by the blunt lobes at the base, rather than long, pointed ones.

Harebell
Campanula rotundifolia

Harebell (*Campanula rotundifolia*) is common throughout New Brunswick and coastal Nova Scotia, but is found only in a few localities in Prince Edward Island. It is often found in coastal or alpine conditions, needing only the barest of soil in cliff crevices on windswept shores, headlands, fields and gravelly streamsides. Brilliant blue or blue-violet flowers appear throughout the summer, until September. Its wiry stems can be up to 40 centimetres tall. The stem leaves are nearly grasslike, but those at the base of the plant are round or heart-shaped.

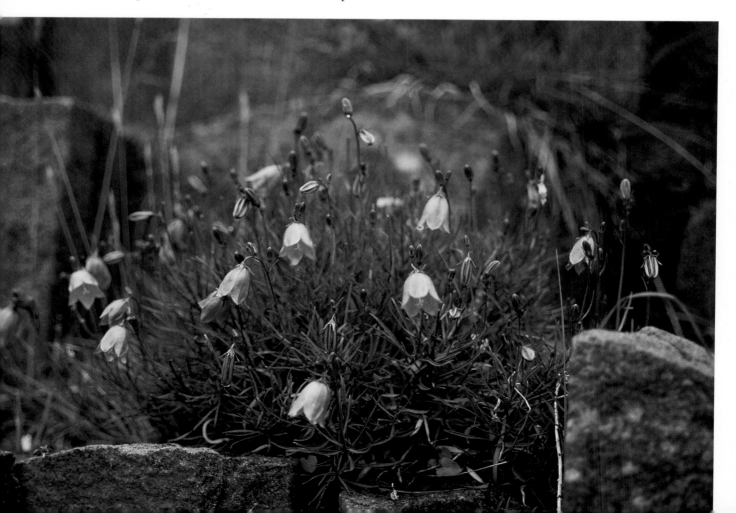

Musk-mallow
Malva moschata

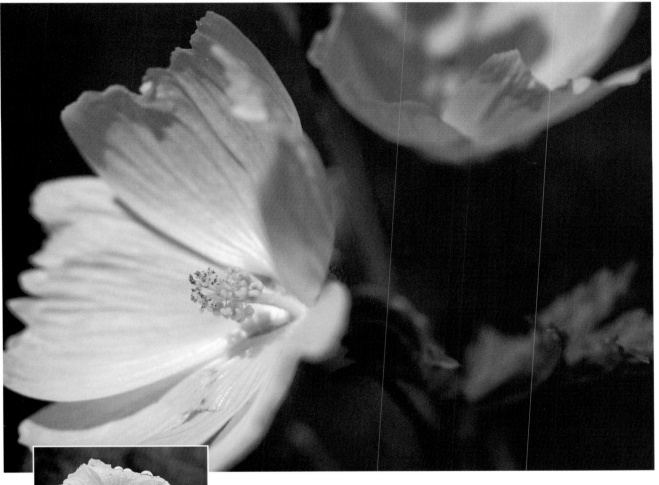

Musk-mallow (*Malva moschata*) is scattered or common throughout Nova Scotia, New Brunswick and Prince Edward Island. Escaped from cultivation, colonies of these pink or white summer-flowering plants may be seen around old houses, roadsides and in fields. The leaves are deeply cut. They are the tallest of our mallows, ranging 30-60 centimetres in height.

Marshmallows were once made from the sticky latex contained within the plants.

Turtlehead
Chelone glabra

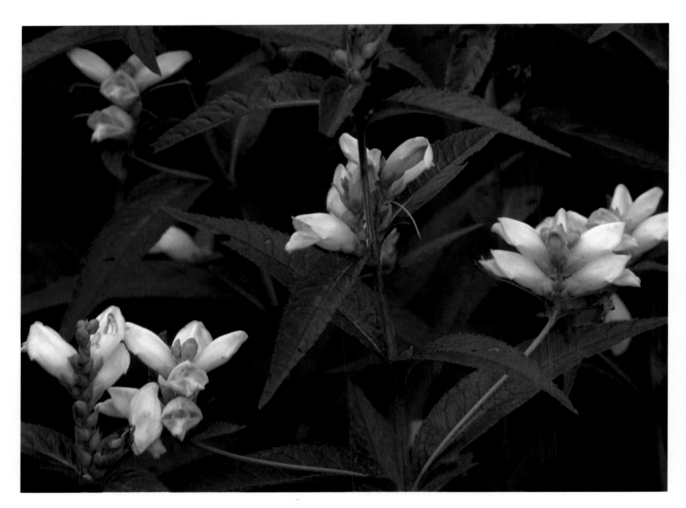

Turtlehead (*Chelone glabra*) is relatively abundant in all three Maritime provinces. Usually in shady areas, it favours stream edges, wooded hollows and damp meadows. The clusters of white flowers, resembling the head of the reptile for which it is named, are found from July to September. It is not uncommon to find individual flowers with a pink blush. Stems may reach one metre tall, with pairs of dark green, toothed leaves along its length.

Ragged Fringed Orchid
Platanthera lacera

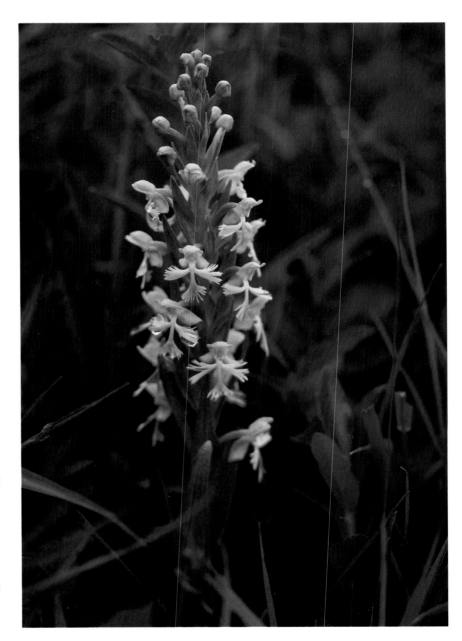

Ragged Fringed Orchid (*Platanthera lacera*) is found throughout Prince Edward Island, southern New Brunswick and Nova Scotia. Flowers arise in July and August, ranging from greenish white, creamy or pure white, on stems up to 80 centimetres tall. Favouring poorly-drained soils, it is to be expected in grassy meadows, marshes and roadside ditches. The lower petal — the lip — is finely dissected into three fringed lobes. Each fringe is also forking, which distinguishes it from white forms of Purple Fringed Orchid. Also, its leaves are narrower and more grasslike.

Fireweed
Epilobium angustifolium

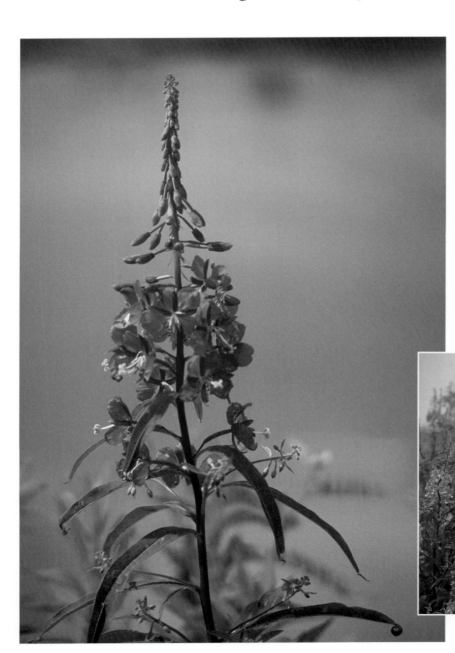

Fireweed (*Epilobium angustifolium*) is abundant throughout Nova Scotia, New Brunswick and Prince Edward Island, especially in open, cleared areas where the soil is dry. Reaching over two metres in height, pink flowers are produced from July to September. The leaves are staggered along the stem. It is often confused at a distance with Purple Loosestrife, which grows in wetlands. The purple flowers of that alien species have six petals and opposite or clustered leaves, while Fireweed has four petals. Fireweed is so-called because it quickly colonizes burned land, especially that of conifer trees.

Tawny Cottongrass
Eriophorum virginicum

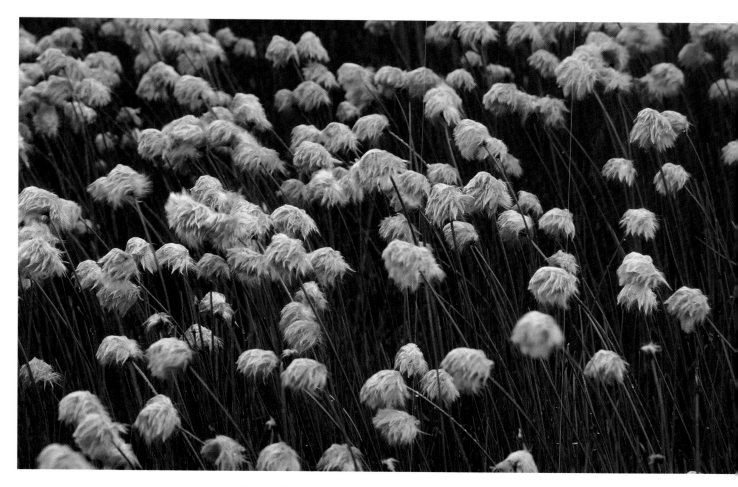

Tawny Cottongrass (*Eriophorum virginicum*) is scattered throughout New Brunswick, Nova Scotia and Prince Edward Island. Limited to wet, acidic soils, it frequents peat bogs and swamps. This species is the last of the cottongrasses to flower, in late July and August. The shining tawny bristles on the seeds give the appearance of miniature, rusty cotton bolls, hence the English name. Leaves are grasslike with sharp edges, but the colour of the heads will distinguish it from the white-bristled species. Plants stand nearly a metre in height.

Water Horehound
Lycopus americana

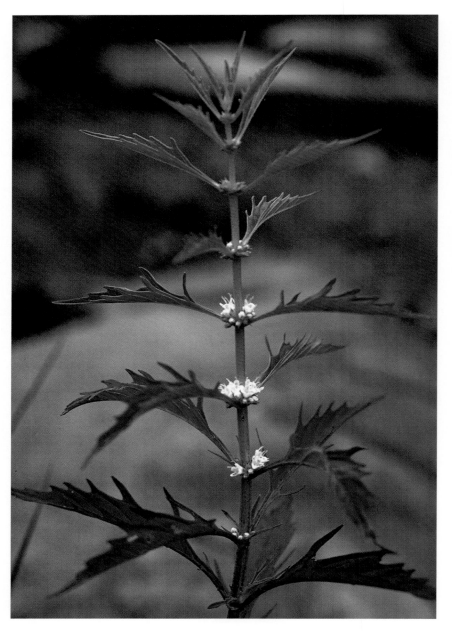

Water Horehound (*Lycopus americana*) is scattered to abundant throughout the Maritimes. Frequenting wet, mucky soils, it is often found along rivers and streams, and in meadows, marshes or ditches. This herb grows as high as 60 centimetres. The numerous clusters of tiny, white flowers mature from July to October. They hug the stem at the base of leaf pairs. Each leaf is deeply cleft. While a member of the mint family, the Water Horehound is scentless and probably not of culinary importance.

Brass-buttons
Cotula coronopifolia

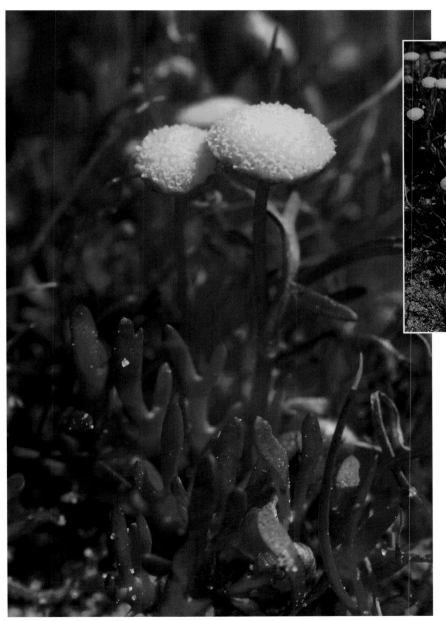

Brass-buttons (*Cotula coronopifolia*) is very local in its Maritime distribution, known from only a couple of stations in each of the Maritime provinces. Limited to coastal regions, look for this herb on the edge of brackish ponds and in salt marshes. The plant is a trailing perennial as tall as 10 centimetres. Its neat, button-like golden flowers appear from July to September. Fleshy foliage is scattered along the stems, long and narrow in outline, or sometimes forking. No other plants resemble it within its habitat.

White Fringed Orchid
Platanthera blephariglottis

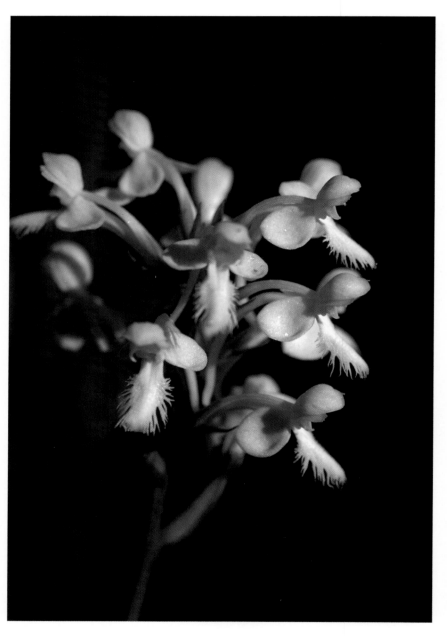

White Fringed Orchid (*Platanthera blephariglottis*) is an uncommon or rare species in New Brunswick, Prince Edward Island and Nova Scotia, limited to peat bogs or meadows. This tall orchid bears fragrant white flowers from July to September on leafy stems up to 70 centimetres tall. The lowermost petal has a fine fringe around its edge and a long spur behind it. Its fragrence is reminiscent of cloves as is that of another native orchid, but no other orchid resembles it in height.

Water Smartweed
Polygonum amphibium

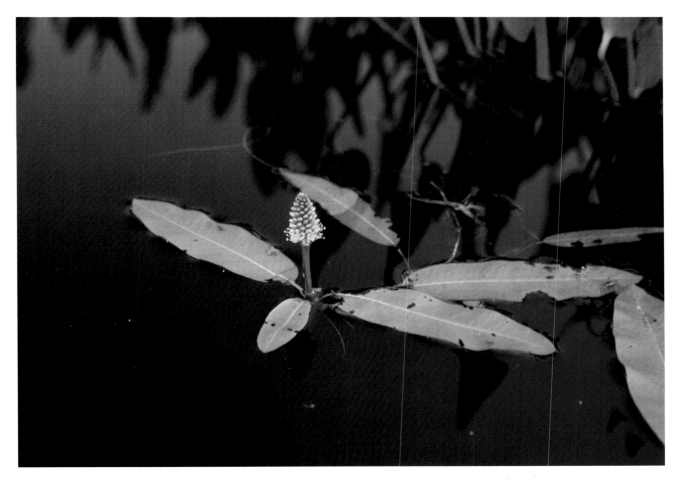

Water Smartweed (*Polygonum amphibium*) is common in northern New Brunswick, on the north shore of Prince Edward Island and in north-western Nova Scotia. It prefers the shallow waters of lakes, ponds and ditches, or the mucky soils bordering them. The cylindrical pink flower spike is produced from July to September. Highly variable in height and leaf shape, the aquatic form has floating leaves, while those plants stranded on mud tend to be erect. Of the smartweeds and knotweeds, this species is one of the most beautiful.

Common Milkweed

Asclepias syriaca

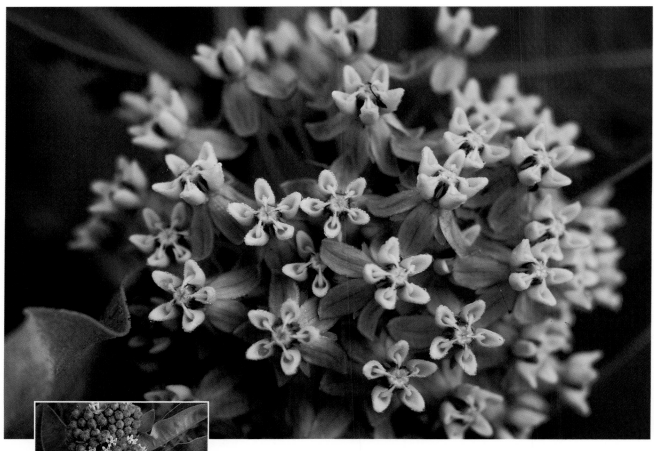

Common Milkweed (*Asclepias syriaca*) is found in all three Maritime provinces. In southern New Brunswick, it is locally abundant along roadsides, fields and thickets, while in Nova Scotia and Prince Edward Island, it was long associated with railroads. This is the plant that attracts the Monarch Butterfly.

Covered with downy white hairs, this is a tall herb, reaching nearly 2 metres. The opposite leaves have clusters of purplish flowers arising from the axils during July and August. Seed pods are covered with bumps and when split, reveal many seeds, each with plumes of white bristles.

Floating Heart
Nymphoides cordata

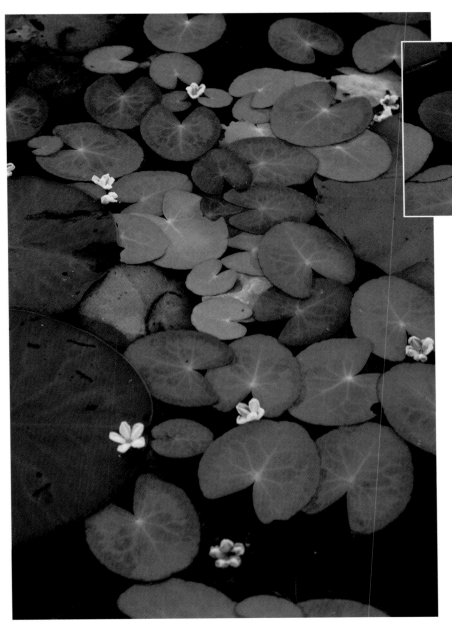

Floating Heart (*Nymphoides cordata*) is scattered throughout New Brunswick and Nova Scotia, but only locally abundant in Prince Edward Island. Growing in mucky soil or floating in shallow, quiet waters, each plant has several heart-shaped leaves up to eight centimetres long and on limp stems. A cluster of small white flowers arises from the base of a leaf from July to September. Water-lily and Pond-lily often grow side by side with Floating Heart, but the leaves of both of those plants are much larger, and their flowers are showy.

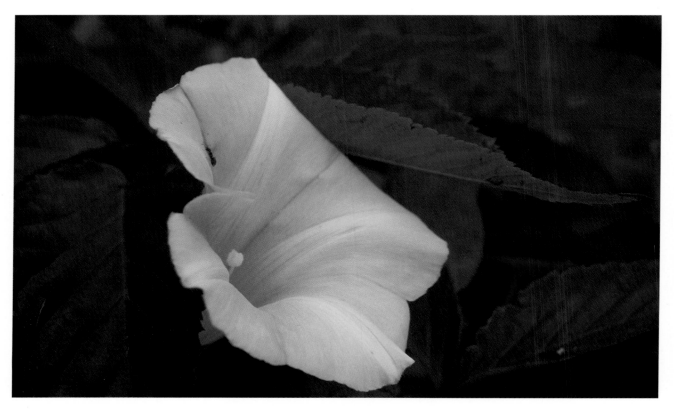

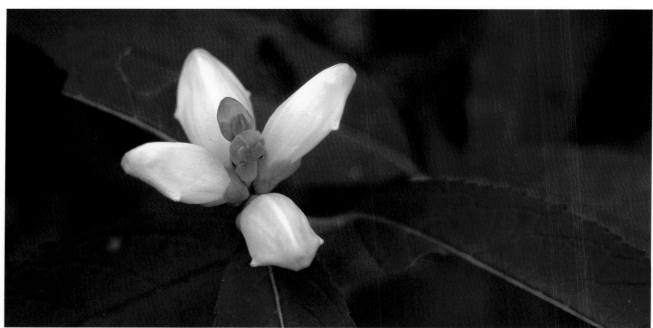

Late Summer & Fall

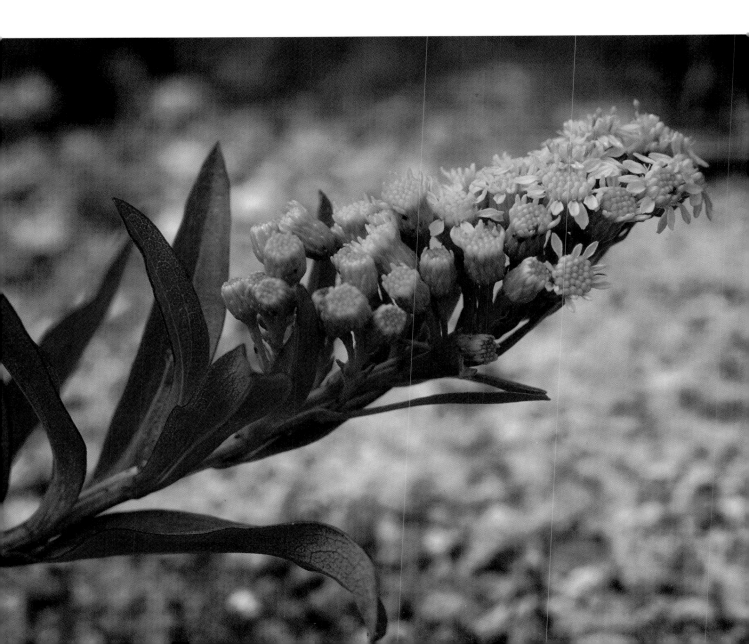

Grass-pink
Calopogon pulchellus

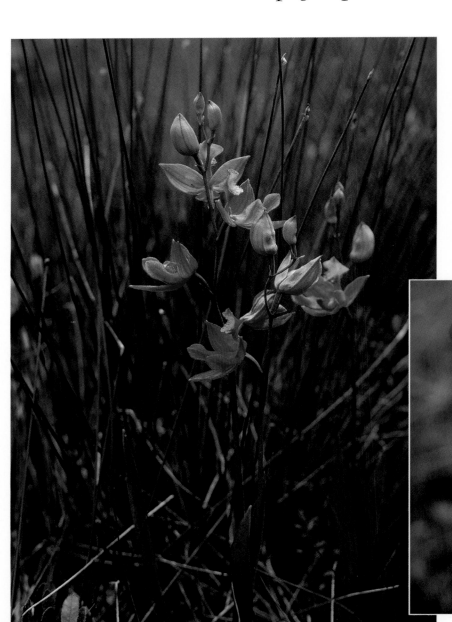

Grass-pink (*Calopogon pulchellus*) is scattered throughout Nova Scotia, New Brunswick and Prince Edward Island, in wet acid soils of peat bogs, swamps and meadows. Two to ten pink flowers arise at the top of a stalk 50 centimetres tall, usually during July. Resembling Dragon's-mouth, they may be separated by the upper position of the yellow spotted lip. The single, long and narrow leaf is present at bloom, while that of Dragon's-mouth emerges after flowering.

Queen Anne's Lace
Daucus carota

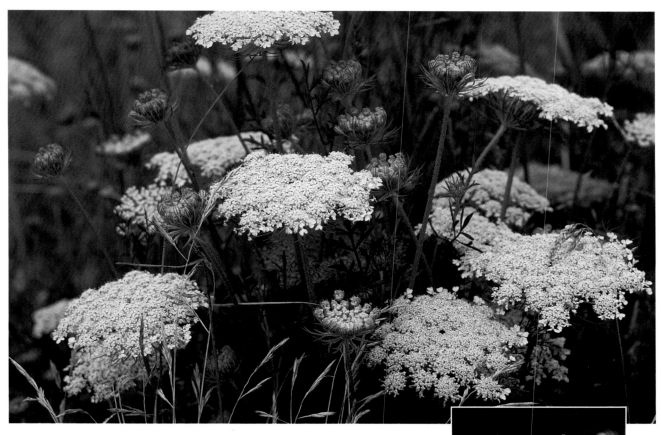

Queen Anne's Lace (*Daucus carota*) is abundant throughout Nova Scotia, but uncommon in New Brunswick and Prince Edward Island. Roadsides, fields and meadows are fragrant with the lacy flowers from July through September. Umbrella-shaped flower clusters are carried above the fernlike foliage. Each cluster has a single purple flower amidst the white ones. Old flower heads resemble bird's nests. Plants stand up to a metre tall. Queen Anne's Lace's lightly hairy stems and leaves distinguish it from Wild Caraway.

It is also called Wild Carrot. The young roots, if cooked, may be eaten like garden carrots, of which it is an ancestor.

Purple Loosestrife
Lythrum salicaria

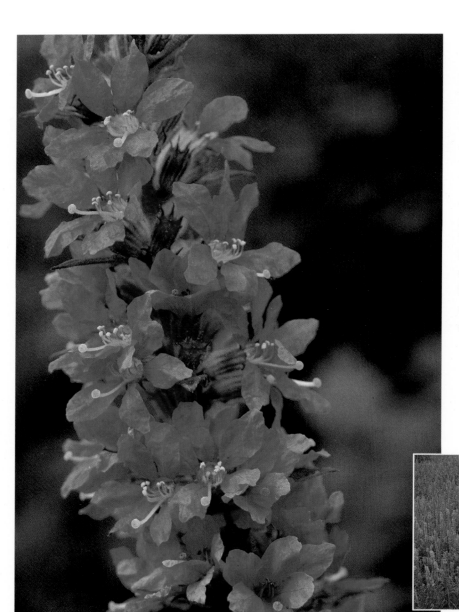

Purple Loosestrife (*Lythrum salicaria*), a rapidly spreading introduction to all of Maritime Canada, thrives in road-side ditches, marshes and on lakeshores. Preferring wet soils, the tall spikes of magenta flowers appear during July and August growing up to 1.5 metres tall. These are followed by copious amounts of seed. Attractive as an ornamental and often planted, Purple Loosestrife now threatens to replace native species from the wetlands to which it spreads. Fireweed is somewhat similar, but its lighter pink flowers are attached to the stem by short stalks. It also prefers dry upland soil.

Butter-and-eggs

Linaria vulgaris

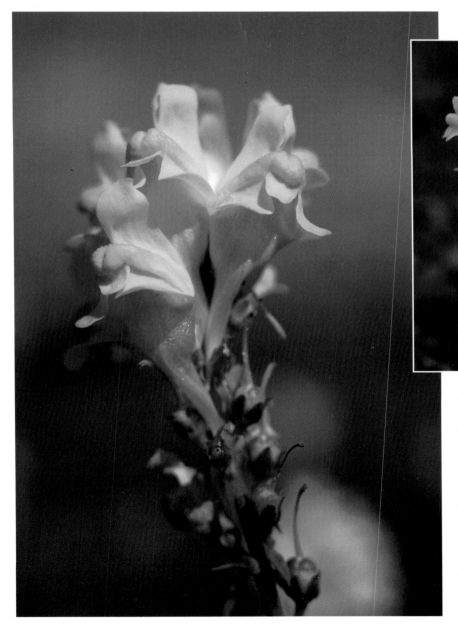

Butter-and-eggs (*Linaria vulgaris*), a naturalized Eurasian plant, is common throughout Maritime Canada. Favouring dry, sandy soils, it is especially frequent on roadsides, along railroads and in fields. The sunny yellow and orange flowers, visible in July and August, resemble miniature snapdragons, to whose family they belong. Soft green leaves are clustered in whorls along the stems beneath the flowers. Height varies from 40–80 centimetres.

Purple Fringed Orchid
Platanthera psycodes

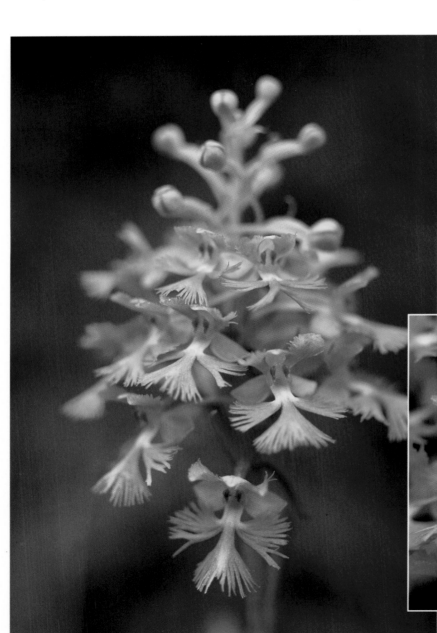

Purple Fringed Orchid (*Platanthera psycodes*) is scattered throughout Nova Scotia, New Brunswick and Prince Edward Island. This small-flowered orchid prefers thickets along rivers, streams, meadows and marshes, and blooms from June to August. The lower lip of the flower is divided into three lobes, each of which is further cut to a fine fringe, giving the flowers a ragged appearance. All shades from white to purple are found, often growing together. The shiny green leaves are largest at the bottom of the plant, which can reach 1.5 metres tall.

Virginia Meadow-beauty
Rhexia virginica

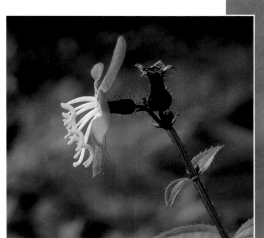

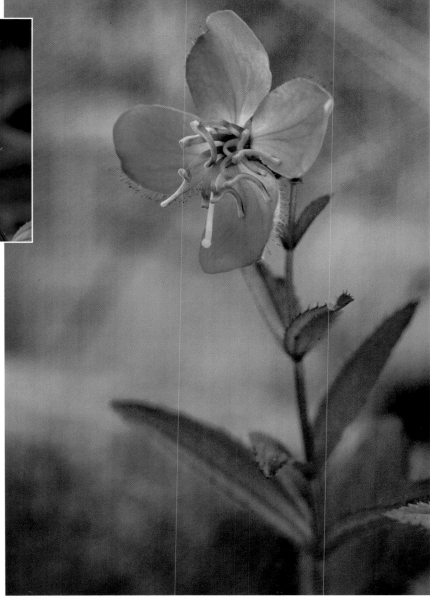

Virginia Meadow-beauty (*Rhexia virginica*) is limited to southwestern Nova Scotia. Considered rare in Canada, it is locally abundant in the sandy soil of wet meadows and lakeshores. The beautiful pink flowers are produced from July to September. Plants may be 40 centimetres in height, the ridged stems carrying pairs of toothed leaves. It is unusual in having the yellow stamens forked, rather than straight beneath the anthers. Growing in similar habitat to Pink Tickseed, Meadow-beauty has only four petals and forked stamens, while the other has many rays and a tight cluster of disk flowers.

Dusty Miller
Artemisia stelleriana

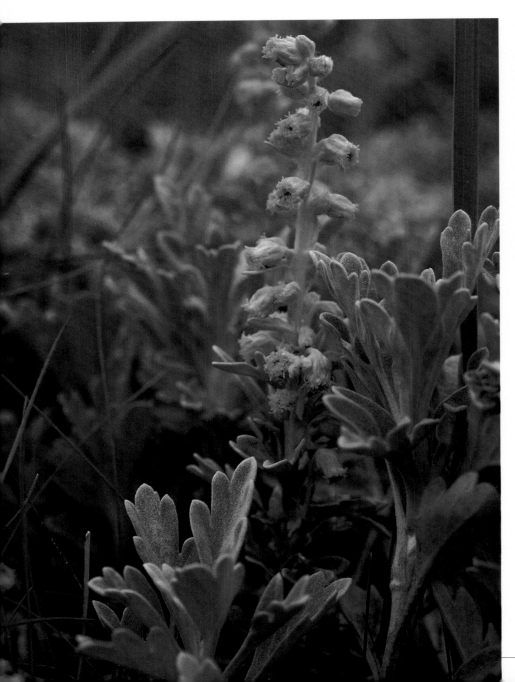

Dusty Miller (*Artemisia stelleriana*) is common along the coast in Nova Scotia and New Brunswick, and locally introduced to Prince Edward Island. Growing along the edge of the high tide mark, this alien plant is associated with sand or gravelly seashores. The rayless yellow flowers arise in July and August. A creeping herb, it reaches no more than 30 centimetres tall. The stems and lobed leaves are covered in white felt-like hairs. Annual bedding plants also named Dusty Miller are related, as is absinthe, a plant from which a liqueur flavouring is extracted. Tarragon, a popular dried herb used in vinegars is also an *Artemisia*.

Sea-lungwort
Mertensia maritima

Sea-lungwort (*Mertensia maritima*) is scattered along the seacoasts of Nova Scotia and New Brunswick. It is limited to sandy, cobbly beaches. This prostrate fleshy herb produces bell-like flowers in shades of pink, blue and white, from July until September.

Like other borages, the flowers are carried in a coiled cluster, unfurling as each opens. The blue-green leaves and coarse stems form attractive wheel shapes amidst pebbles, rooting in sand.

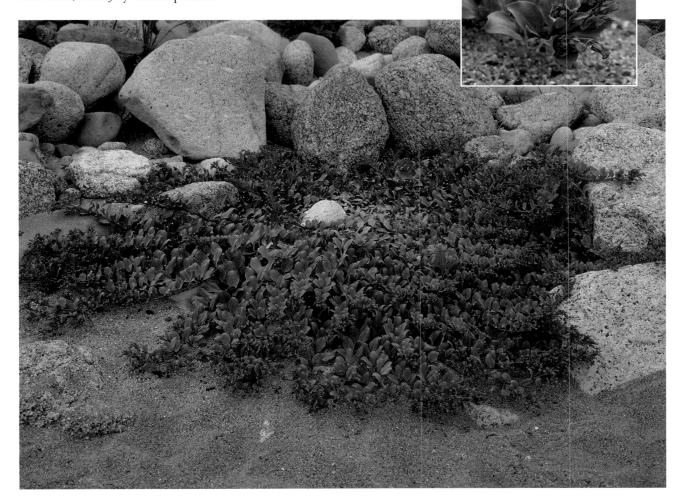

Canadian Burnet
Sanguisorba canadensis

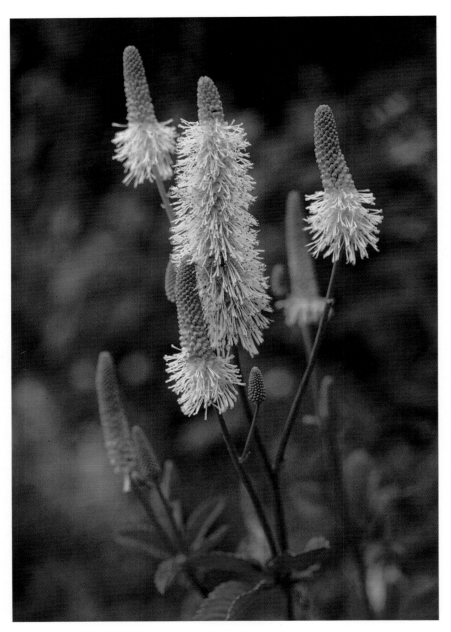

Canadian Burnet (*Sanguisorba canadensis*) is locally common in northeastern New Brunswick, along the coastline and in northern Nova Scotia, but absent from Prince Edward Island. Burnet favours wet soil in meadows, swamps or bogs. The bottlebrush-shaped spike of flowers is produced from July to October. Plants may reach one metre in height. Leaves resemble those of roses; they are divided into toothed leaflets numbering up to 15. Unlike roses, they are not shrubby and are not armed with thorns.

Pink Tickseed

Coreopsis rosea

Pink Tickseed (*Coreopsis rosea*) is only located along the sandy or peaty shores of a few lakes in Yarmouth County, Nova Scotia. Indeed, this county boasts the only Canadian population of one of our loveliest wildflowers, which blooms during August and September. The daisy-like flowers have pink (rarely white) drooping rays, with yellow disk flowers in the centre. Very narrow leaves are paired on stems up to 60 centimetres tall. Whilst this species is listed as endangered in Canada, several other, golden-flowered relatives are cultivated annuals and perennials.

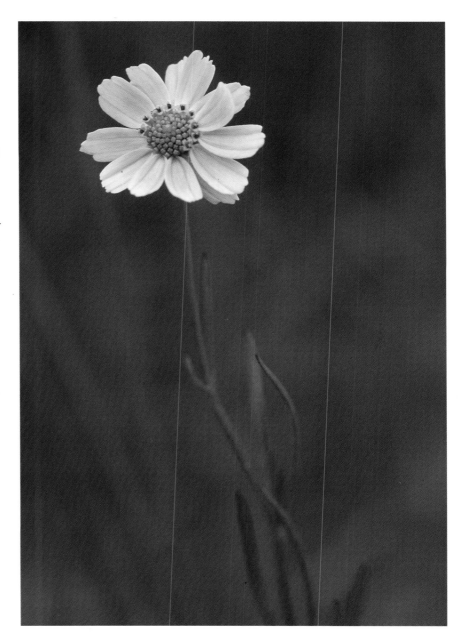

Pearly Everlasting
Anaphalis margaritacea

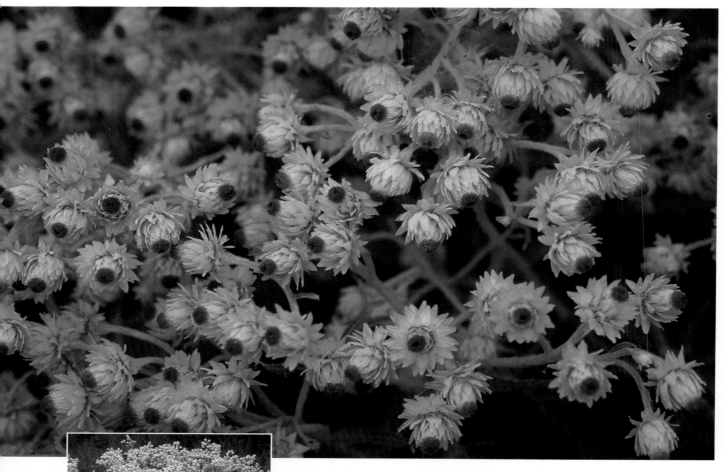

Pearly Everlasting (*Anaphalis margaritacea*) is a very common summer wildflower in the three Maritime provinces. Frequenting dry, open sites, colonies persist in fields, roadsides, sand dunes and forest openings. Flowers appear anywhere from July to September, remaining until October.

They are everlasting because of the series of dry, petal-like bracts which surround the tiny flowers. Plants may reach 90 centimetres in height. The leaves are softly hairy.

Dried flower arrangements may be kept indefinitely by air-drying the flowers and stripping the leaves.

Seaside Goldenrod
Solidago sempervirens

Seaside Goldenrod (*Solidago semper-virens*) is scattered to abundant in coastal areas of New Brunswick, Prince Edward Island and Nova Scotia. An inhabitant of damp sands and mucky saltmarshes, it may often provide the dominant colour in a landscape where grasses and sedges lend only shades of green and brown. The golden yellow flower heads are showy with seven or more rays surrounding the disk. They are in evidence from August until late October. The dark green leaves are fleshy. Height at flowering varies from 30 centimetres to over one metre.

Nodding Ladies'-tresses
Spiranthes cernua

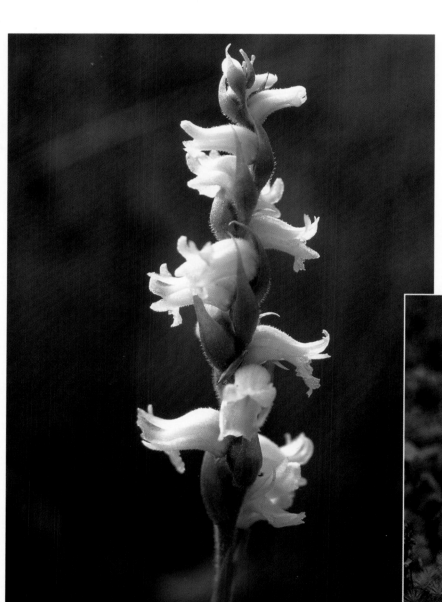

Nodding Ladies'-tresses (*Spiranthes cernua*) is limited to Nova Scotia and southern New Brunswick, where it frequents bogs, meadows, roadside ditches and gravel pits. Flowers appear in August, remaining until October atop a slender stem up to 45 centimetres tall. They are arranged in a double spiral. Grasslike leaves are largest at the base of the plant. This species is difficult to distinguish from the Hooded Ladies'-tresses, commonly encountered in all Maritime provinces.

Plymouth Gentian
Sabatia kennedyana

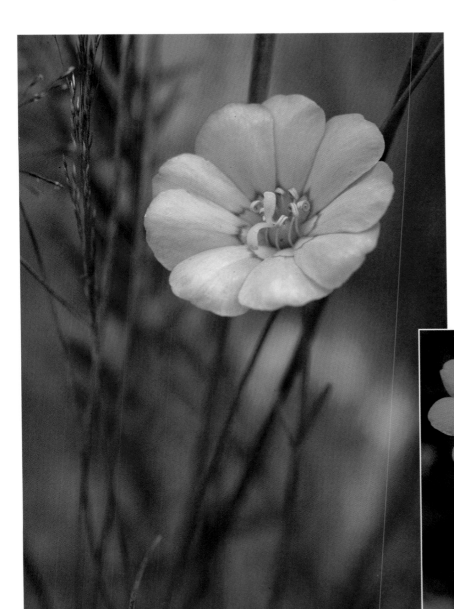

Plymouth Gentian (*Sabatia kennedyana*) is restricted to Yarmouth County, Nova Scotia. It prefers cobbly sand and peaty soil, growing only on several lakeshores and in wet meadows. The fragrant pink and yellow flowers do not appear until August, showing themselves from the upper part of a 60-centimetre tall stem. Leaves are narrow and paired along the stem. Due to the plant's rarity in Canada, it has been designated threatened. Nova Scotia's few localities represent the entire Canadian population of this beautiful wildflower.

Hop Clover
Trifolium aureum

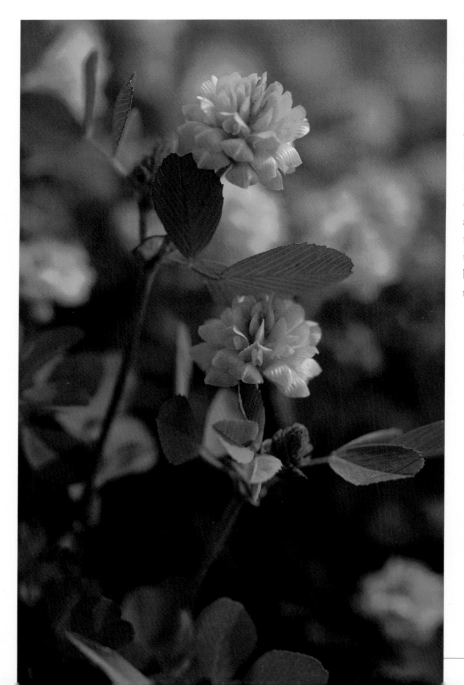

Hop Clover (*Trifolium aureum*) is common throughout the Maritimes, especially along roadsides and edges of fields — places where it has escaped from cultivation. The yellow flower heads are visible from June to August. After blooming, they promptly droop and turn brown, resembling hops, after which they are named. The leaflets are in threes with one notched at the tip. It is short in stature rarely exceeding 30 centimetres. Sometimes mistaken for Medick, this little clover may be distinguished by its dry brown seed heads, rather than Medick's black-coiled pods.

New York Aster
Aster novi-belgii

New York Aster (*Aster novi-belgii)* is scattered or common throughout Prince Edward Island, New Brunswick and Nova Scotia, along highways, in fields and in other damp sites. The rays vary in colour from pale mauve, blue and nearly pink to violet, with yellow disk flowers, appearing August until October. Plants vary in height from 15 centimetres in coastal habitats to over one metre. The leafy stems are smooth and hairless, unlike New England Aster, which may also have rosy coloured rays.

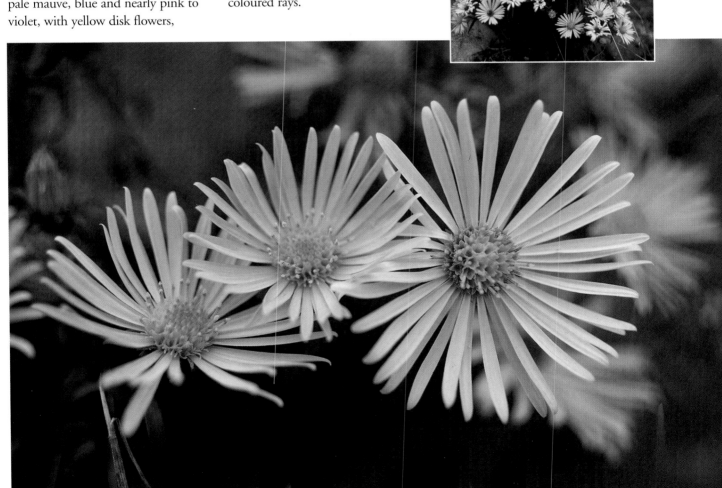

Red Clover
Trifolium pratense

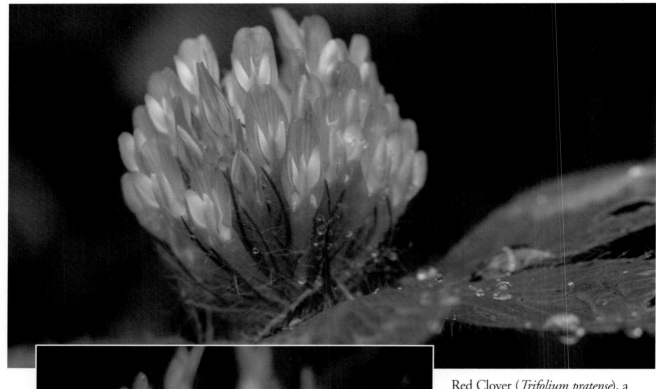

Red Clover (*Trifolium pratense*), a common escape from cultivation, is abundant in all three Maritime provinces. Favouring roadsides, fields and meadows, it is often planted for hay mixtures. The soft pink or reddish flowers are produced from June to November, on stems reaching 40 centimetres in height. The sweetly fragrant blooms are clustered in a round head. Red Clover makes an excellent tea if the flowers are first dried.

Downy Rattlesnake-plantain
Goodyera pubescens

Downy Rattlesnake-plantain (*Goodyera pubescens*) is a very rare orchid, found in Maritime Canada only in several areas in Nova Scotia. The tight cylindrical flower cluster tops a leafless stem, 40 centimetres tall, covered in white downy hairs.

Flowers are produced during July and August. Like other Rattlesnake-plantains the leaves are green and distinctively marked with a network of white veins. The hairy stems should distinguish this species from similar orchids.

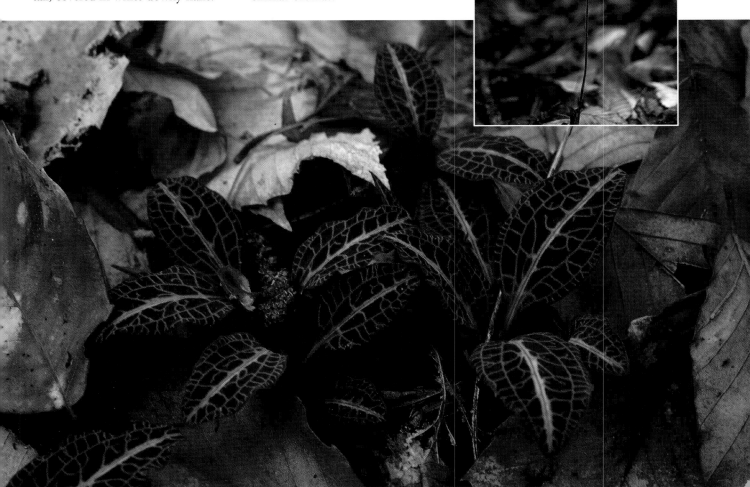

Index